A Popular History of
WESTERN NORTH CAROLINA

A Popular History of
WESTERN NORTH CAROLINA

MOUNTAINS, HEROES & HOOTNOGGERS

Rob Neufeld

Rob Neufeld

Charleston London

History
PRESS

Published by The History Press
Charleston, SC 29403
www.historypress.net

Cover image: A series of paintings in the council chambers of Asheville City Hall depicts the transition from Cherokee to colonial society and the period of violence in between. Art Deco architect Douglas Ellington had hired Clifford Adams to do the paintings; Adams escaped history's notice afterward. *Photo by the author.*

First published 2007

Manufactured in the United Kingdom

ISBN 978.1.59629.183.6

Library of Congress Cataloging-in-Publication Data

Neufeld, Rob.
A Popular History of Western North Carolina : Mountains, Heroes & Hootnoggers / Rob
Neufeld.
 p. cm.
 ISBN-13: 978-1-59629-183-6 (alk. paper)
 1. North Carolina--History. 2. Frontier and pioneer life--North Carolina.
3. Cherokee Indians--North Carolina--History. 4. North
Carolina--Biography. I. Title.
 F261.N48 2007
 975.6--dc22
 2006034632

Notice: The information in this book is true and complete to the best of our knowledge. It is offered without guarantee on the part of the author or The History Press. The author and The History Press disclaim all liability in connection with the use of this book.

Naturally, as a historian, I dedicate this book to my idealistic and good-hearted parents, Rena and Alfred Neufeld.

Contents

CONTENTS

Preface

There are never too many historians. My special interest has been to convey broad themes through very particular, personal stories. I am attached to this approach for a few reasons.

First, I want the stories to be interesting. The closer the focus, the better, I think.

Second, a big obstacle to understanding history is the strangeness that attaches to worldviews experienced in different places and times. The way to overcome this is through research and empathy—that is, by walking in another's shoes.

The third reason for the human interest approach has to do with truth. I once had a professor who growled the phrase "inter-subjective objectivity" to mean "the closest we can get to truth by combining different takes on it."

Tell the stories and let the truth follow, I feel. However, I will state conclusions now and then—more for emphasis than definitude. Passionately, one can say: there are things we must learn from history. (Unfortunately, one of the things we learn from history is that people rarely ever learn from history.)

Still, after attempts to communicate through analysis, I hastily return to parables and—even better—the re-creation of experience. In personal stories, conclusions aren't neat. They multiply and overlap, creating something dramatic rather than static.

The best example of this discovery is the history of the Civil War in Western North Carolina. Come to a conclusion about the Civil War in this area based on one study, and you'll find yourself legitimately contradicted by another story or by another interpreter. There seem to be as many explanations of the war as there are people who were involved in it.

I have been lucky to have author Terrell Garren as a companion-in-research for some of my Civil War writing. He is an exacting and open-minded historian, and at times we've pored over simple statements to see if they violated any version of truth.

One result of this work is that I've developed an unending interest in the Civil War—I've joined the crowd! The Civil War is one of the five themes covered in this book—a collection of articles I've written for the *Asheville Citizen-Times* under the heading "Visiting Our Past." I intend for this book to stand alone as well as to lead to additional volumes, covering other themes.

PREFACE

There is something beautiful in the book-of-columns format. Among other features, it's expandable. An authoritative chronological work has a hard time accommodating revisions. Revisions are a critical part of history writing. My columns for the *Citizen-Times* turn out to be a community process. I hear from readers—with additional stories, with additions to existing stories and with corrections.

If I were to write a chronologically organized tome, I would start with geology—and then proceed to natural history, economy and society. I would not abandon my personal, close focus approach. I imagine starting with lines such as these: "Pick up a rock—not just any rock. Go to the Beaucatcher Cut along I-240 in Asheville and pick up a pre-Cambrian rock. It tells a story."

This relates to what I consider another key concept in writing history: pertinence. A story about 500,000,000-year-old rocks does not stand alone as a curiosity; it connects naturally to contemporary issues and episodes—the story of its blasting and its effects, the study of soils in the area and the prospect of development along the ridge.

The *Citizen-Times*, in its public spirit, has allowed me to work the material that had been commissioned by it; and I have worked it some—adding new material as well as many transitions. The History Press has given me the great opportunity to share the history further. In agreeing to work with this publisher, I knew of the fine job they've done with a writer of this region I admire greatly, George Ellison.

Again, I stress, history making is a communal process. I welcome responses.

Part 1
The Cherokee

Putting a Human Face on Our Region's Ancient Settlers

We need to connect with a spirit—someone from a former time who reveals the drama of his or her life through stories or documents. But how do we put a human face on the movements of our region's first settlers—those Indians who entered our dark mountain forests about ten thousand years ago, when the warming earth urged exploration?

Those early settlers were masters at living in the wilderness throughout the year without the benefit of agriculture or clay pots. They enjoyed their style of living so much that when the people of other regions, thousands of years later, began switching to a mostly sedentary life in the bottomlands, the Appalachian natives stayed in the uplands—or kept two homes. Eventually, around AD 200, the majority of mountain natives began to adopt the settled way of life of their distant kin in Tennessee and Georgia.

"Why didn't they take up civilized life along the rivers earlier?" I asked Dr. Anne Rogers, field archaeologist and chairperson of the Anthropology and Sociology Department at Western Carolina University. "A better question might be, why did they quit being hunter-gatherers at all?" Rogers answered. "Things had been going so well."

A lot of archaeology is speculation—after one goes through the painstakingly careful work of sifting through and preserving sites and of sorting things out in the lab. Unfortunately, many types of artifacts do not survive in our soil because of its acidity and moisture content. Yet, Rogers can look at the topography and the plant record and surmise that the early natives were heavily dependent on nuts. Along with butternut, beech, hickory and oak, there had been large groves of chestnut trees in the primeval forest. Nuts provided protein and fat to people and were easily grindable and storable.

"When the chestnut groves were there," Rogers mused, "you wouldn't believe the number of animals that congregated—deer, raccoons, groundhogs, bears." Pigs—those prodigious nut-eaters—had been absent. They arrived with the Spanish conquistador, Hernando De Soto, in 1540, and became favorites of the Cherokee, who relished their fatty meat. Before that, bear meat had been coveted for its fat.

Part 1: The Cherokee

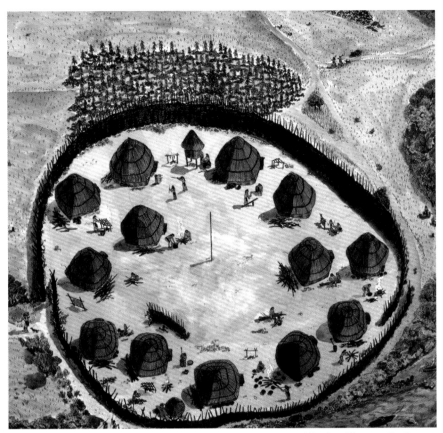

By the second millennium, the Cherokee had come to live a middle-class life in such places as the Swannanoa River Valley, illustrated here by Gwen Diehn for Warren Wilson College's archaeology program.

Bears were sacred animals to the natives, we may assume—for not only did they provide a dietary staple, but they were also the dominant animal in the woods, and their feet and carcasses eerily resembled those of humans. James Mooney, the ethnographer who collected traditional tales from the Cherokee from 1887 to 1890—long after contact with Europeans altered their original content—records a story about the genesis of bears that seems to contain an ancient core.

In the Cherokee myth "Origin of the Bear," a boy convinces his family to leave their village and live in the woods. "I find plenty to eat there," he says in the Mooney version, "and it is better than the corn and the beans we have in the settlements." At a council meeting, the parents state, "Here we must work hard and have not always enough. There he says there is always plenty without work." So, the villagers go off into the woods and turn into bears. The last words they say to the human relatives they leave behind are, "When you yourselves are hungry, come into the woods and call us and we shall come to give you our own flesh."

There is another Cherokee myth, "Origin of Disease and Medicine," which also seems rooted in the time of the native people's abandonment of animal ways. The animals complain about how Man abuses and slaughters them, and they invent diseases as retribution. Plants, friendly to Man, then offer a remedy for each malady.

When the ancient people moved into this area, they inherited a land short on rich bottomland soil but rich in plant diversity. By moving around, they were able to make use of a great variety of plants and they became experts in herbal medicine. This is a legacy they share with mountain people today.

Some archaeologists also assume that the early natives remained isolated in their coves, and that this explains why, for a long period of time, they used only local materials for their weapons. Rogers refutes this theory. First of all, the pre-European people were not limited to paths that horses or carts could travel. They walked, and they often walked along ridges and down from ridges. The landscape was well marked by a network of Indian trails.

At hunting camps and small habitations throughout the mountains, archaeologists have discovered that the Archaic and Early Woodland natives made spear points out of quartzite as opposed to the easily workable chert, for which they could have traded. Why? One would have to assume that the quartzite worked well. Rogers says that it worked better for such tools as scrapers. To make a quartzite point, you fractured it with another rock, picked the best pieces and did some tooling. In other words, it took less finesse than working with chert, but managed to serve the natives' hunting needs for thousands of years.

You can imagine the men going off on long hunting trips; they set up hunting camps and had butchering stations. Meanwhile, the women were doing what? Collecting and preparing food, making baskets and articles out of animal skins, accompanying the men? It's hard to tell. With later periods, evidence of women's activity is judged by the presence of pottery, but to guess what the earliest Indians had done for thousands of years, we have to take reckless leaps.

Looking at hunting-gathering cultures that have been documented, we see how women had been very much engaged in crafts. Not only was there a lot of leisure time in pre-modern societies, but the individuals also made good use of their leisure. They were busy working and talking.

Styles changed slowly, and when they did, it was often because of a cultural invasion or a reaction to cultural invasion. From 4,000 to 3,000 BC on the Appalachian Summit, the natives stuck with a kind of spear point—called the Guilford point—that was completely foreign to the ridge-and-valley residents. In other words, these people had regional consciousness. They weren't isolated, for the mica, copper, quartzite and steatite found here were desired by the people of other regions and were sometimes traded. Mica had only one use then: ornaments.

Part I: The Cherokee

By the first century BC, life in these parts began to change radically. The ancestors of the Cherokee may have come at that time, and they may have brought corn culture. Such imprecise scientific methods as glottochronology—the graphing of language change—suggest that the Cherokee language split off from an Iroquois root about two thousand years ago.

Corn was the major impetus in the establishment of agricultural communities. In this region, at the same time that farms, riverside villages, pottery and family burials increased, there was also a great increase in cave-dwelling. Is this an indication of an ousted set of people such as the bear-people?

By AD 1000 the Cherokee began growing beans. Corn and beans supplied so much nutrition that the balance swung toward village life, and a population explosion ensued. There are a handful of Cherokee village sites in this area that have become well known because of the archaeological work done there: the Warren Wilson College site in Swannanoa, the Garden Creek site near Canton and the Macon County Industrial Park site, among others.

Anne Rogers has worked with Western Carolina students at the Appletree camping site in the Nantahala Forest for seven years, funded by the U.S. Forest Service, and at the Wayehutte site in Jackson County with gifted high school students in a state-funded program called Summer Ventures. Rogers notes that Indian sites are everywhere. In this area, the Indians especially liked alluvial or colluvial fans, places where mountain rivers broadened, such as at Warren Wilson or Apple Tree. In these places, we find the layered evidence of successive settlements from 10,000 to 500 years ago.

For 1,500 years before the arrival of Europeans, the Cherokee lived what might be considered a middle-class life. The typical neighborhood grouped several homes around a plaza and was in easy distance of a local ceremonial and trade center. Society comprised well-developed economic and occupational classes.

Artists stamped pots with favorite geometric designs and shaped clay into figurines. In or just outside their houses, Cherokee homeowners had storage pits, fireplace hearths, clay pits, kilns and family graves. Some homes had cellars.

Rogers recalls an exciting discovery at the Apple Tree Camping site. She noticed a dark stain in an area that had once been the floor of a house. Digging, she recovered pottery shards from the Qualla period (around AD 1450) along with three musket balls. The pit she had found had probably been a storage area, like a cellar, but the balls were out of place.

Can we imagine a little family drama? Perhaps some permissive parent's child played with his father's ammunition, and then hid it. The look of innocence on the child's face is completely forgotten, but the proof of his panic emerges five hundred years later.

Reviewing the Myths

We come back to the Cherokee myth "Origin of the Bear," collected by turn-of-the-century ethnologist James Mooney. A boy convinces his family to return to woodland living, where the food source is reliable and requires less work. Departing, the family transforms into bears, and the boy calls back, "We are going where there is always plenty to eat. Hereafter we shall be called yânû [bears], and when you yourselves are hungry, come into the woods and call us and we shall come to give you our own flesh. You need not be afraid to kill us, for we shall live always."

While most Cherokee moved into the low, fertile land by the rivers at the beginning of the millennium, many chose to stay in the mountains and many kept two homes. An archaeological site by the Swannanoa River, unearthed by David Moore and others on Warren Wilson College property in 1982, has revealed its occupation by four successive Indian civilizations. Big digs such as this support theories about river culture. Yet, further research throughout the region has uncovered many modest wilderness homes situated by upland creeks and cliffs.

The wilderness calls. With the advent of corn, the Cherokee came to embrace a middle-class style of life that included settlements, farms, decorated pots, family burial plots, cupboards, ceremonies and government. The same period of time witnessed an unprecedented increase in cave dwelling.

"We shall live always," the bear people had said, but one wonders. The black bear remains the great sacred beast of the Smokies, but today it is threatened—down to one thousand in number in their Great Smoky Mountains habitat. The spirit of the bear people—wilderness living—confronts civilization and development at every turn.

In 1540 Hernando De Soto, a fierce Spanish explorer, led his troops from Florida to East Tennessee through either the Hickory Nut or Swannanoa Gap. White men, horses, pigs, guns and disease came to Buncombe County. The area was kingly rich in nut-bearing trees (bear paradise and pig heaven), but the Spanish were after precious metals. Discovery of copper to the west of Buncombe and gold to the east inspired a succession of Spanish miners, rough parties whom later explorers report encountering.

In 1670 the first permanent white settlement in the Southeast planted itself in the Charleston vicinity. Immediately, the Charlestonians set up a vigorous trade with the Cherokee for animal pelts. In return, the Cherokee sometimes got rifles, which they could use to produce more pelts. Animal populations—and the ways captured by the myths Mooney collected—declined.

Part I: The Cherokee

The Legendary Pharmacopoeia

"The Origin of Disease and Medicine" depicts a later time. The Woodland Cherokee have developed a fearsome technology—bows and arrows—and have been fruitful and multiplied, disturbing the ecological balance and causing animals grief. They have even begun to neglect singing the proper songs.

The bears call a council—somewhere near Clingman's Dome—and consider shedding their claws so that they too might shoot arrows, but it is too much of a sacrifice. They cannot assimilate such a lifestyle.

Deer convene. They feel less of a kinship with humans than do bears. They inflict rheumatism on those men who fail to respect animals' sacrifices. Other creatures inflict other ailments, and humanity seems on the brink of being eradicated, when the plant world responds with a catalog of remedies.

Rheumatism must have been a common malady among the ancient Indians. It gets first billing. For a cure, according to Mooney, a shaman would call on dogs of heaven—mythic enemies of mythic deer—while applying a decoction of fern roots.

Rheumatism especially affected natives' legs. It was envisioned as a wormlike intruder, thus explaining the remedy of fern spirits, a tapeworm antidote. Lumbee Indians of Piedmont North Carolina applied a poultice of pokeweed berries to arthritic limbs.

To the Cherokee and pre-Cherokee, the world was not only physical but also metaphorical, and truth lay where both realities agreed. This was especially true of the Archaic Indians, who roamed from wilderness camp to camp, not bound to agricultural fields nor graced by surplus goods kept in pots.

Though the Archaic Indians, living several thousand years ago, used a spear-thrower called an atlatl, they had no bows and arrows. In the mythic framework, they were friendlier to the bears than Woodland Indians, and ecologically similar to them.

To what extent did the Archaic Indians suffer from rheumatism? They may have lived shorter lives. Ballgames would not have preoccupied them. Their diets would have been more varied. Thus age, wear and tear and nutritional deficiencies—three causes of rheumatism—might have been less present. Rheumatism may have become, in the ancient time frame, a "modern" disease.

What would have been the Archaic male's thoughts as he walked through the bog where the eight-foot-tall pokeberry grew? He was in his prime as the crafty king of the forest, and the world was his pharmacopoeia.

In the spring, tender pokeweed shoots would provide him with a blood-enriching salad—as delicious as honey to bears, once the poison had been boiled out. He and his cronies might find a slow-to-go bear lodged in a high tree hollow and force it into a vulnerable position by means of fire. When warm weather came, he'd grind

buckeye nuts into creek pools, doping the fish in order to scoop them out as easily as did a bear, which was no longer on equal footing.

As the Bear Goes, So Go We

A s black bears increase in number and enter our subdivisions, residents are stirred by an ancient connection. The black bear is the totemic animal of this region. But what does that mean?

Cherokee myths establish the kinship of humans and bears, which had once been human and had split from the tribe. Natives and pioneers have noted that when a bear is skinned, it looks surprisingly human. Long, long ago, when animals and people were on speaking terms, bears sacrificed themselves to support humans.

By the time that John Lawson—gentleman surveyor hired by Carolina's Lords Proprietors in the first decade of the 1700s—tramped all over the province, the bears' and the natives' era of glory had already passed. "The Small-Pox has destroy'd many thousands of Natives," he wrote in his report, "[who] sling themselves over Head in the Water, in the very Extremity of the Disease; which shutting up the Pores…drives it back; by which Means Death most commonly ensues."

The British supplied the Indians with guns to advance the fur trade. Lawson envied the more cooperative trading methods of the French. The English, however, brought a popular diversion to wilderness society—sport hunting—which also appealed to the natives, who equated hunting prowess with manliness.

"Bear-Hunting is a great Sport in America," Lawson wrote, "both with the English and Indians. Some Years ago, there were kill'd five hundred Bears, in two Counties of Virginia, in one Winter."

In the days when bears had been sacred, the native religion involved many functional connections with the animal. The meat of the bear, first of all, was considered the best available, except when the bears had been on a heavy fish diet. Bear fat yielded a thermal skin lotion, a high-energy drink, a pain-relieving salve, cooking oil and cosmetics essential to many rituals.

"I prefer their Flesh before any Beef, Veal, Pork, or Mutton," Lawson wrote of bear venison, noting that the fat, "as white as Snow," was "the sweetest of any Creature's in the World. If a Man drink a Quart thereof melted, it never will rise in his Stomach."

Part I: The Cherokee

There was much to admire about the bear's spirit. She-bears are very rarely caught. They hold off letting their eggs become fertilized until they are in their caves and can bear young in secrecy, states the North Carolina Wildlife Resources Commission's DVD *The Bear Facts*. In hibernating, bears need neither to feed nor eliminate wastes, yet they maintain their muscle structure. Doctors, the DVD reports, are studying the bear's unique hibernating functions "to benefit a wide variety of people from kidney patients to those suffering from osteoporosis."

There's a kind of reverence involved in this modern search for improved life. In the 1970s, the wildlife commission instituted reverence by establishing twenty-eight black bear sanctuaries in the state. At the same time, bear conservationists find themselves managing the latest signs of the totemic animal's status: depredations of livestock, collision with cars and suburban dumpster diving.

A Digression
The Bear Hunters of Dillingham

True bear hunters are rarer than bears these days. Hunters require early training on the trail, like hound pups. It also helps to be descended from a bear hunting family.

Local bears, encouraged by the current climate to produce larger litters, are spilling out of woodlands into suburbia. In their clash with expanding civilization, their biggest advocates are the bear hunters.

Hoyte Dillingham of Dillingham grew up in a bear's suburb—that is, within a crescent of prime bear habitats—the Bee Tree and Asheville watersheds and the Mount Mitchell area, all off-limits to hunters. When boar bears roamed for a mate in the late spring, they took stock of nut-bearing trees there and returned in the fall if necessary.

"When I was six," Hoyte recalls, "I would go with my father [Lester Dillingham] on hunts. The men would load all the dogs on a truck…and if they had to leave me at the camp, they'd put big rocks in front of the truck wheels. I would listen to the dogs." Back home, Hoyte continues, the men "rendered the fat and cooked and canned the meat. It was like filet mignon. Bear back in those times were flavorful because they fattened on wild chestnut."

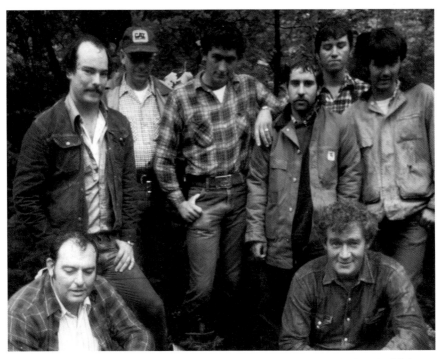

Bear hunters from Dillingham (near Barnardsville) introduced hunting with dogs to Michigan. Pictured here on a trip are (clockwise from left) Hoyte Dillingham, Dan Morgan and Jimmy Hickey from Spruce Pine, Michael Rice from Dillingham, Doug Bezona and his friend Chad from Washington, and Charles Hensley and Bill Rice from Dillingham. *Photo courtesy of Hoyte Dillingham.*

Lester Dillingham was descended from Big Ivy's first settlers. He established a general store in Dillingham, operated a bus fleet serving factory workers throughout the county and owned the area's first Plott hound, given him by the Plott family when the dog had been rescued during Fontana Dam's construction. His bear hunting buddies included Dillingham store regulars—Clintons, Bankses, Brigmans, Carsons, Anderses, Rices—as well as the legendary Clarence "Duck" Boone from Marion, a Daniel Boone descendant.

Duck Boone owned an explosives supply company in Spruce Pine and a rock quarry in McDowell County. He was known to distribute hundred-dollar bills to charities and impoverished individuals. He also funded bear hunting trips in RVs to Michigan, where he introduced dogs to hunters accustomed to still hunting (baiting and waiting).

Hoyte Dillingham is a legend himself, having registered Plott hounds with the American Kennel Club in the 1950s and helped name the Plott hound the state dog a decade ago. In 1991 he found himself in a hospital undergoing heart bypass surgery.

Part I: The Cherokee

"When I got home," Hoyte says, "if I had arms long enough, I would have hugged my house." Then, he recounts, "the preacher ran over to say there was a bear at the church [Dillingham Presbyterian]…Charles Hensley, a neighbor, went and caught the bear in his arms, got scratched some. We put it in a crate. I'd been lying in the hospital praying that I could go hunting again, and the Lord is so good, he sent me a bear—and he sent it to the church!"

The bear—a starved yearling—ended up at the Western North Carolina Nature Center, according to Hoyte's demands, and was released into the wild a year later.

Biggest Bears

Perhaps the two biggest bears hunted in this region over the last century appeared fifty years apart, and Tucker Anders of Dillingham was involved with both of them. Anders is one of the veteran hunters in the Pisgah National Forest area whose ancestors have passed on the tradition within families.

A couple of years ago, Anders was camping near Pensacola, when two of his buddies, out collecting wood on a lumber road, saw a couple of fair-sized bears returning from a foraging expedition. An approaching big snow accounted for both the human and ursine activities.

Alerted back at camp, the men let loose their hounds, prized Plotts trained by Hoyte Dillingham and his expert partner, Charles Hensley. Fallen snow had already smothered bear tracks and scent, but the dogs sniffed fur-brushed bushes until a trail dog scratched his way under a pile of tree tops heaped up by a lumber company.

Suddenly, five grown bears came out of the tangle, the biggest one not running, perhaps having decided to sacrifice himself once his lessers had foolishly revealed themselves to people. "That was the most exciting thing I ever saw in my life," Anders says, "those black bears coming out. They were so dominant against the white snow."

A half century before, another huge bear was caught in similar conditions— looking to gorge itself for the final time before a freezing storm arrived in the Craggy Gardens territory. Normally, bears there took sanctuary in watershed zones, off limits to hunters; but good food could lure hungry animals away.

It was in a beech tree grove that teenagers Tucker Anders and Sammy Hensley saw bear-raked dirt. The two fast, tough fellows set two fast, tough dogs on the bear's trail, dashing and crawling through laurel thickets and rock clefts for two miles. When they found the bear's nest, they called the pack, which cornered their prey against a cliff. From a hundred feet above, the hunters viewed the stalemate and delivered the fatal shot.

The adventure wasn't over. Anders and Hensley had to leave and return with additional men, tow sacks and flashlights. Night had come. Men expert at butchering had to dress the bear on the spot, and it took ten men to haul half the

meat. "Some of the men fussed because Sammy brought the hide out and left some of the meat," Anders says.

Anders's father, John, fainted from a minor heart attack, having trudged home heavily laden, and having had to lift his legs high in the ground-covering dog hobble. Hensley's trophy hide covered a garage door and then a barn side in Dillingham for years before falling apart. Bear hams the size of footlockers filled a Dillingham General Store meat case. Two weeks after the kill, the men went back to Craggy to retrieve meat that had been hanging in trees through an icing storm; but the bear parts were gone, scattered like the mythical Osiris.

Strawberries in Legend

On his first foray into Western North Carolina in 1775, botanist William Bartram was greeted by the sight of young Cherokee women cavorting in fields of strawberries. He was staying at the home of Gallahan, chief trader in Cowe (Macon County). "Beloved by the Indians for his humanity," Gallahan was deemed unlike most "white traders [who] give great and frequent occasions of complaint of their dishonesty and violence."

Bartram and another trader rode into the Cowee Mountains. Amid "turfy knolls," they found a vast meadow "embellished with parterres of flowers and fruitful strawberry beds…Companies of young, innocent Cherokee virgins" reclined in the shade, "bathing their limbs in the cool fleeting streams; whilst other parties, more gay and libertine, were yet collecting strawberries or wantonly chasing their companions, tantalizing them, staining their lips and cheeks with the rich fruit."

Strawberries are a cultivated plant, as were the corn and beans that Bartram had seen in the natives' vast and well-tended plots. The Elysian fields were part of an advanced society—as Bartram and his pal had experienced when female elders dispelled their libidinous fantasies.

Yet Bartram, the expert, had overlooked the natives' scientific management of the landscape because, as Charles Mann points out in his book *1491*, "The surgery was almost without scars; the new landscape functioned smoothly, with few of the overreaches that plagued English land management."

The Cherokee reserved wild land to serve hunting and gathering needs. On cultivated terraces, they grew a surplus of plants to ensure the good life. The strawberry was a symbol of it.

Part I: The Cherokee

According to Cherokee myth, women had something to do with creating civilization. After an argument with the first man, the first woman left their forest home. Pursuing her, the man gained the aid of the Sun, which tried tempting the woman with blueberries and blackberries. No sale.

Then the Sun tried strawberries and the pleased woman lost her anger. Today, strawberries are kept in Cherokee homes as symbols of marital harmony.

Do our current crops provide legends for our modern age? Here's one.

Bert Fridlin, an Atlanta lobbyist, moved to Ox Creek with his wife Ginger to manage a berry farm owned by Terrell Jones, whose family had been devoted to fruit for generations. For years, it had been apples. But the apple business has been disfavored by problems with spray, bee mites and low profits.

As the region's orchards and tobacco fields have yielded to subdivisions, Jones has encouraged managers to try different fruit. Steve Yokim and Fridlin's daughter, Melissa, came to the farm a few years ago and planted organically grown blueberries and strawberries.

Bad rains and a blight in 2003 led to the Yokims' departure in 2004, at which point the Fridlins took over. Dogwood Hills Farms now contributes to the health movement in farming (blueberries have antioxidant properties) as well as to the health of Bert Fridlin. Fridlin had wandered from the city to the farm to recover from stress-related symptoms that warned him against pesticides and called for exercise and strawberries.

Quest for Cherokee History

Portraying history can be as dramatic and controversial as participating in it. The Cherokee epic drama *Unto These Hills*, a huge boost to the Cherokee economy in 1950, was rewritten and restaged fifty-six years later with an eye toward authenticity and in the face of commercial risk.

The reconstruction of one's people's past must depend, in the case of traditional and non-ruling cultures, on oral traditions, spotty written documents and sometimes questionable authorities. James Mooney's *Myths of the Cherokee*—an invaluable source—is a third-hand record of sacred lore divulged to a white man. Some of the most established facts about Cherokee history waver when called into question by scholars of various stripes.

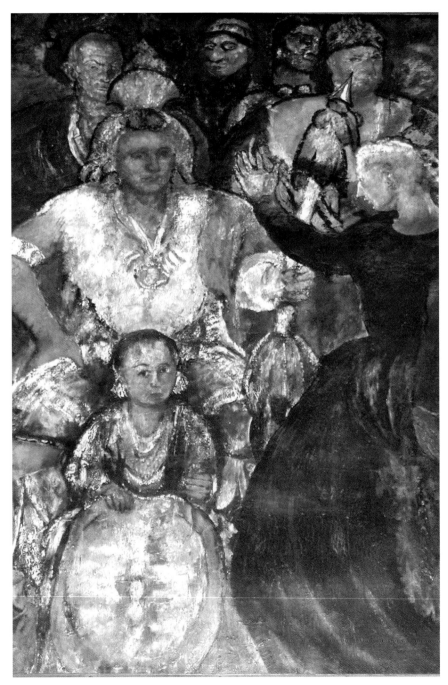

A series of paintings in the council chambers of Asheville City Hall depicts the transition from Cherokee to colonial society and the period of violence in between. Art Deco architect Douglas Ellington had hired Clifford Adams to do the paintings; Adams escaped history's notice afterward. *Photo by the author.*

For instance, Sequoyah, the great American hero: he may not have invented the Cherokee syllabary, as textbooks claim.

There's evidence that the Cherokee had a written language long before Sequoyah supposedly invented the eighty-five-symbol syllabary now in use. And there's a possibility that the Sequoyah put forward in the 1840s—and in the accepted portrait—was not the real one.

The main source for this information is a 1971 book *Tell Them They Lie* by Traveller Bird, who professes to be a descendant of the true Sequoyah, or George Guess, whose Cherokee name was Sogwali. In 1871, Traveller Bird reveals, Sogwali's daughter, Gedi, wrote her grandchildren that the people who wrote about Sequoyah in a current issue of *Harper's* "are pretender liars."

"That picture I saw of the man they call Sogwali is a joke…That is not the way he looked. My father Sogwali had no ears, no long fingers. They cut [them] off. That picture is a fraud. That man is Thomas Maw [another Cherokee leader]."

Sogwali, according to Traveller Bird's account, had been a member of a scribe society who had decided to make the society's language available to all Cherokee in order to resist European acculturation. He resisted inclusion in Indian Territory and in the Eastern Cherokee's land, moved his people to Texas and Mexico and was captured and mutilated. Later, Traveller Bird describes how white society concocted a myth by which the all-Cherokee Sogwali was said to be the son of a white man, George Gist, a friend of George Washington.

Parts of Traveller Bird's rendition are persuasive. We have examples of Cherokee writing before Sequoyah—but were they an alphabet or only pictorial symbols? Sequoyah resisted internment in reservations, and a group of Cherokee moved to Texas and Mexico—but was Sequoyah captured and mutilated?

Complications arise from the fact that no one has been able to find the author, Traveller Bird, though his book was published in 1971 and followed, the next year, by a second work, *The Path to Snowbird Mountain*, a collection of Cherokee legends. Nor has anyone ever discovered the letter Traveller Bird cites as having been written by Sequoyah's daughter.

Thrillers have been written about the search for arcane literature. The search for Traveller Bird may be as dramatic as what he purports.

John Ridge Was Not Simply a Traitor

John Ridge and members of the Cherokee Treaty Party agreed to have the Cherokee leave their Southern Appalachian homeland in 1835, despite opposition from a huge majority of Cherokee. According to Robert V. Remini, an award-winning Andrew Jackson biographer, Ridge and his cohorts may have been marked for assassination because of this treachery. At any rate, they were killed a few years later.

There's more to the story. The famous 1831 Supreme Court decision that denied Georgia the right to evict or prosecute Cherokee landholders also decided not to enforce their protection. President Andrew Jackson also played hands-off. Consequently, land- and gold-hungry intruders attacked the Cherokee without restraint. Ridge was reacting to the specter of decimation. In the history of dispossession in this region, community members often divide over how to respond to the threats, and the dividers take advantage of the rifts.

Missionaries Did Not Teach the Cherokee Christianity

Baptist and Methodist missionaries tried to transmit Christian theology, but the words of their sermons and the Bible did not translate. For instance, the Cherokee believed in multiple souls or life forces. Saving one's soul made little sense and was translated as something that approximated "helping one's soul."

In the Cherokee cosmos, spirits resided above, on the earth and below; as well as in the east, west, north and south. Yet Christian Heaven was translated as "above." The Lamb of God became a young deer. The term chosen to denote "Christmas," Alan Kilpatrick explained in a 1995 article for *American Indian Quarterly*, meant "they are shooting them [game animals]." It "has no religious overtones," he noted. "Rather, it connotes a festive occasion when one feasts on fowl."

The subject of the survival of Cherokee religious beliefs and their assimilation with Christianity is pregnant with historical questions, insights and pertinence. The subject unfolds before us as the Eastern Cherokee renovate and expand the Museum of the Cherokee Indian.

Emissaries and Speculators

In 1739 a slave ship pulled into Charleston, carrying smallpox. The virus traveled with the fur traders into the mountains and destroyed half the Cherokee population in one year.

When the French began to make inroads into Cherokee country from their growing empire along the Mississippi River, the British responded with the presentation of a celebrity, Sir Alexander Cuming. From Charleston came Cuming, full of pomp and ceremony, to persuade the Cherokee to become British subjects. Foster Sondley described the Cherokee reaction to Cuming in his classic, *A History of Buncombe County, North Carolina*.

Part I: The Cherokee

"The Indians enjoyed the whole absurd performance," Sondley wrote, "and were most wonderfully impressed with the greatness of the performer, although they did not comprehend what it all was about."

A few years later, the French sent a German Jesuit emissary, Christian Priber, to the Cherokee towns to stir up anti-British sentiment. Priber shed his European self, adopted Cherokee ways, and became a folk hero. In the mode of Mr. Kurtz, the cult leader in Joseph Conrad's *Heart of Darkness*, Priber organized a militant Cherokee republic of which he was the charismatic chief.

Eventually captured by the British, Priber died in a Georgia prison. His influence, however, contributed to the French and Indian War in 1754 and other warring acts against British and American settlers for several decades.

The American impulse to find good land and become one's own man is an overwhelming one. Among the local colonists, the urge proved so forceful that the Cherokee defended themselves by becoming allies with their former enemies, the British, in the Revolutionary War. In reaction to Cherokee attacks on Old Fort in 1776, American General Griffith Rutherford blazed a path of vengeance all the way to what is now Murphy, destroying a few dozen Indian towns in one month.

On the way, Rutherford camped at Bench Bottom along what is now Sand Hill Road in West Asheville. The giant arrowhead monument in front of the Accelerated Learning Center, formerly Aycock School, on Haywood Road is said to mark Rutherford's Trace.

Among the victims in Old Fort in 1776 were John Davidson and his family. The Davidsons represented one of the most astounding exodus stories in history—that of the Scots-Irish, whose impulse to find a home for their people, free from political and economic persecution, stayed pure over the passage of several generations and several thousand miles.

In the Scottish highlands on the English border, in Ulster County, Ireland, and in Pennsylvania, Maryland, Virginia and eastern Carolina, the Scots-Irish were perceived as threats to the established powers. Coming to the Southern Highlands after having played a decisive role in the Revolutionary War, they found a place where they were European first-comers—and a place that looked like home.

Certain Cherokee met the first Anglo settlers in Western North Carolina with violence, but the Treaty of Hopewell in 1785 legitimized the land claims west of the Blue Ridge and led to a flood of speculators and pioneer immigrants.

A Powder Horn Recalls a Turning Point in British-Cherokee Affairs

Attakullakulla, fifty-year-old Cherokee statesman, came to Fort Ninety Six on the Cherokee border in May 1761 to stop what seemed to be an inevitable disaster.

As a nineteen-year-old, Attakullakulla had met King George III in London and endured the pomp. In his thirties, he'd been a prisoner of war in Canada. Lately, he'd been playing Virginia against South Carolina in their battle for commercial supremacy.

He knew what storm clouds looked like.

Ninety Six had been a prosperous trading post and not much of a fort, yet it was suddenly bursting with military activity. Newly shipped British soldiers, American militia, members of scattered Native tribes, wagon masters, tradesmen, drovers and a staggering assemblage of horses and cattle stirred about, announcing the feared launching of Colonel James Grant's expedition of revenge.

Grant had gotten orders to "chastise" the Cherokee for their defeat of the previous year's British expedition, led by Colonel Archibald Montgomery. Cherokee-British relations had gone bad since 1758, when twenty Cherokee warriors, fighting for the British against the French in Virginia, were killed and scalped by settlers who'd thought they were collecting bounties on French allies.

According to the Cherokee law of "corporate responsibility," Cherokee leaders sought to take the lives of twenty members of the Virginians' clan. They "repeatedly asked what clan the white people were," Barbara Duncan writes in the Museum of the Cherokee Indian's guide to its exhibit Emissaries of Peace, "and were told that they [the white people] were all the same clan." So the Cherokee attacked men in the Yadkin River Valley in North Carolina.

"An eye for an eye" was the law of the Cherokee—to achieve balance and end warfare. But the British followed a policy of a scourge for an eye. They also practiced divide and conquer.

Chickasaw, Catawba and Mohawk came to Grant and performed war dances—a gesture of friendship. Yet in the current context, Attakullakulla saw social disintegration and mounting fanaticism. He "beg'd the Colonel would have a little patience, 'till he might have time to bring about a lasting Peace," noted Captain Christopher French, commander of the Twenty-second British Regiment, in his journal.

Off to the side, a British soldier, who had evidently served in the navy, carved maps and images into a powder horn in scrimshaw fashion. British conquest advanced along with the arts. Cartography was a supreme form: a rational combination of science, art and expansionism. Ships dock, roads wend and deer prance in the carver's neat vision.

A few weeks later, the powder horn would contribute to Grant's victory at the Cohowee Pass (near present-day Otto) and, subsequently, his destruction of fifteen Cherokee towns. Though the British had promised that those who did not flee would be cared for, soldiers' logs record the killing of stay-behind women and old men.

Part I: The Cherokee

What Timberlake Saw in Chota

When the Cherokee strove to make peace with the British after a series of escalating reprisals in 1761, they asked the British to send a high-ranking ambassador to Chota, the Overhill capital (now below Tellico Lake), as a sign of good faith. No one at Fort Robinson (present-day Kingsport) wanted to go—and be taken hostage if another Cherokee were to die in a colonial attack.

Lieutenant Henry Timberlake volunteered. He would later escort three Cherokee chiefs on a tour of London and write a popular book about his experiences, simply titled *Memoirs*. With evident literary style, Timberlake downplayed his literary skill.

But Timberlake may have harbored a desire to be another Daniel Defoe, author of the 1719 bestseller *Robinson Crusoe*, for there was a market for adventures among exotic peoples told by restless members of the merchant class. Timberlake's account of his time among the Cherokee begins with a Defoe-like reflection: "My father was an inhabitant of Virginia, who dying while I was yet a minor, left me a small fortune, no ways sufficient for my support, without some employment."

In Chota and other towns, Timberlake encountered an old civilization. "When the Europeans brought wool cloth, silk cloth, beads, and brass kettles," says Barbara Duncan, education director for the Museum of the Cherokee Indian, "the misconception is that the Cherokee fell all over themselves to get these items. It's not true. They'd been making cloth, beads, baskets, decorated pots, and feather capes for millennia."

More significantly, the Cherokee had a time-tested philosophy based on maintaining balance in nature and society. European land-hunger and amorality shocked them. William Bartram, the eighteenth-century botanist who recorded his travels in Cherokee country, wrote about an Indian youth who said, "We did not know before they [Europeans] came amongst us that mankind could become so base." He thanked the Great Spirit for favoring the red man.

Europeans were aware of their fall from grace. William Wordsworth wrote in 1806, "The world is too much with us…Little we see in Nature that is ours…I'd rather be a Pagan suckled in a creed outworn." The Cherokee at Chota—descendants of a people who had been reduced 95 percent by warfare and disease and now were accommodating a mixture of Indian refugees—treated Timberlake to a war dance. The war dance was a show of strength, a welcome event and a fundraiser for the community's needy. The dancers dressed up in traditional regalia.

Cherokee dress reveals the importance of craft and beauty in their lives. The ceremonial mantle, for instance, appreciated so greatly by Londoners, derives from a multi-purpose garment draped over the left shoulder to keep the right arm free. Hunter-gatherers had used it for warmth and as a ground cloth. It was elaborately decorated.

Following the dance came a peace pipe. The tobacco-herb mix produced a smoke that carried the smokers' thoughts to the Creator and exposed all lies. Actors performed a bear-hunting mime for Timberlake. A wounded bear figure "rises up again," Timberlake wrote, "and the scuffle between the huntsmen and the wounded bear generally affords the company a great deal of diversion."

In London, the chiefs whom Timberlake escorted enjoyed the pantomimes at Sadler's-Wells, a London theatre, more than the cathedrals. The cultures shared some points of contact. But mostly, the British way of life transformed the Cherokee—through arms and an arms race and through commercial pressures. If balance is the rule in the Cherokee worldview, the story must continue to develop.

Lois Queen and Modern Times

L ois Queen Farthing was born in Smokemont in 1923 on the farm of her grandfather, Harvey J. "Harve" Cooper, an English American who'd married Stacey Sneed, a Cherokee tribe member. As the government acquired land for the Great Smoky Mountains National Park, established in 1934, Lois's dispossessed family replanted themselves on a lot that Lois's mother, Leila Cooper Queen, owned on the reservation.

"We happened to be at the right place at the right time," reflects Lois's daughter, Lyna Ferguson, about the business that was about to develop.

"Mill workers from Gastonia, Spartanburg and Greenville came to the mountains during the summer," said Jim Cooper, Lois Queen's cousin and Cherokee hotelier. "They had no place to stay in Cherokee." They stopped at the Queen residence, which soon included three additional cabins.

"My grandmother would rent rooms and feed the guests," Lyna relates. Leila and her husband, James Candler Queen, had experience running a boardinghouse in Smokemont at the Civilian Conservation Corps camp.

In the late thirties and early forties, the only restaurant in town, Jim Cooper recollects, had been Freeze's Café, where one could get two types of sandwiches—cheese and bologna—and two condiments, mustard and mayonnaise.

The road through town—Route 441—had been nearly impassable at times. "Each time it rained, we had to push cars out of the muddy places," Cooper

Part I: The Cherokee

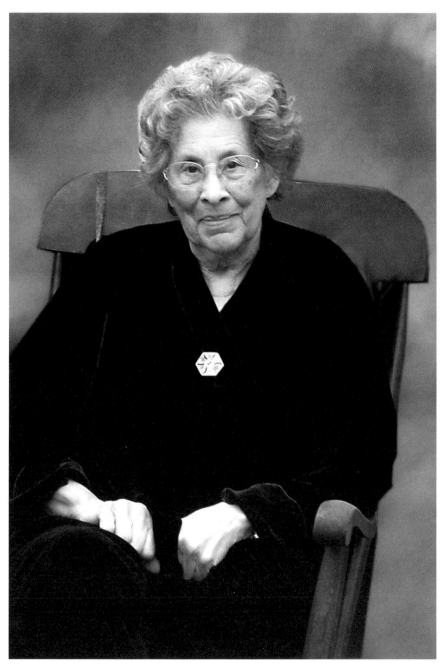

Lois Queen Farthing, Outstanding Native American Business Achiever (awarded by the U.S. Department of Commerce in 1988). *Photo courtesy of Lynn Ferguson.*

says. When the state came to widen and pave it, Harve Cooper tried holding up construction with a shotgun. The road would divide the family farm.

But it was James Candler Queen, a proponent of the road, who prevailed. After all, it was his wife's land. The decision set off an era of unprecedented prosperity.

In 1946 Lois Queen was twenty-three when, working as manager of her parents' businesses, she opened Newfound Lodge, a restaurant and gift shop. Her parents had just taken control of the cabins they'd leased to Etta Hall of Maggie Valley for ten years. Over the next several years, the Queens would build additional facilities, including a Newfound Lodge hotel, Big Boy Restaurant, Comfort Suites, Comfort Inn and, famously, the Pink Hotel.

Lois ran her businesses with a family spirit. Emerging from the era of the Bureau of Indian Affairs' acculturation, Cherokee residents were shy of public jobs. (They did work in the crafts industry.) Lois hired and nurtured African American workers from Hayesville, Waynesville and Sylva. Years afterward, she received letters from former employees who credited their business success to the training she'd given them.

Lyna also worked for her mother. "I started when I was eleven years old—in the Pink Hotel," she says, and she got paid. The Pink Hotel was not only pink on the outside, but had pink linens, upholstery, tiles and matchbooks. The idea originated with a practical consideration—the local laundry was mixing up different hotels' sheets and towels—and Lois wanted to create a distinction.

Little Lyna contributed creatively, too. A Peter Pan fan, she suggested the Tinkerbell icon on the hotel sign.

In 1949 Lois and other members of the Associated Community of Western North Carolina (later the Cherokee Historical Association) brought the drama *Unto These Hills* to town, starting a business boom and a new era. A fourth era—the development of Cherokee authenticity within the tourism business—developed a few years before her death. She died on June 18, 2006.

Steering through the Torrent

People had come to Cherokee for crafts before 1950. But it was the establishment of the drama *Unto These Hills* in 1950 that truly attracted tourists, and they came in torrents. Three thousand people filled the new theater, standing room only, six nights a week, mid-June through Labor Day.

"For us at that time, the drama was as big as the casino is now," reflects Cooper, whose Holiday Inn in Cherokee had been the first hotel to stay open year-round in what has become a cultural as well as tourist mecca. Business more than quadrupled in the 1950s, he says.

Lois Queen Farthing served as a trustee in her mid-twenties on the committee that commissioned the stage attraction. Cherokee leaders had noted the success

FOUND LODGE, CHEROKEE, N.C.
NS, INDIAN HANDICRAFT, DINING ROOM ©MURRAY

The Newfound Lodge—Indian crafts, lunchroom and cabins—is shown here in its early days, before it was expanded to a hotel after the tourist boom that accompanied *Unto These Hills*. *Photo courtesy of Heather Menacof*.

of the Manteo production *The Lost Colony* and hired Kermit Hunter, Chapel Hill drama graduate, to translate their people's epic into pageantry.

Fifty years later, with Lois Queen closing out her influential life, Cherokee underwent another major change, focusing on historical authenticity and the employment of Cherokee people. The drama was rewritten, correcting inaccuracies. Non-Cherokee costumes were out; Tsali, Junaluska and Drowning Bear were no longer portrayed as being part of Oconaluftee. The old ending—a tragedy—gave way to one that revealed the emergent cultural renaissance.

Cherokee in the first decade of the twenty-first century have undergone aesthetic changes, recalling Lois's pioneering interest in beautification. She'd been an art student before assuming the mantle of her parents' property management and had turned this interest toward landscaping. In the late 1990s and early 2000s, Lois's daughter, Lyna Ferguson, drove her around town, where she occasionally stopped to give groundskeepers friendly advice.

"I drove Miss Daisy," Lyna says. "It made her so pleased to ride through Cherokee and see that the fronts of the shops had been fixed, that someone had planted trees."

In Lois's last years, she passed her horticultural passion to her great-grandson, Ellison, who called her GG. "She'd have Ellison planting pansies with a little spade," Lyna relates, "and after a few plantings, she'd get tired."

When Lois stepped into the postwar era of Cherokee development—as a businesswoman, Chamber of Commerce member, Cherokee Historical Association trustee and Sequoyah site preservationist—she entered a forceful current. Carried by it, she also retained her values such as hard work, avoidance of debt, treating employees and associates as family, quiet perseverance and belief in working one's way from the bottom.

It was a strange time. Lois's mother, Leila Cooper Queen, had attended the Bureau of Indian Affairs' boarding school, as had other elders she knew. Lyna's husband's brother's father-in-law, Loyd Bigwitch, told tales of the school, according to his daughter, Mary Jane Ferguson, now the Cherokee Welcome Center director of marketing and public relations.

"We would hear him speaking the language," Ferguson recalls. "I was about eight and asked him, 'Why don't you teach us to talk?' Then he would tell about being punished for speaking Cherokee at the school. He didn't want us to suffer for it."

Lois Queen—as a single mother and woman in business—somehow negotiated the expanded contacts with the non-Cherokee world that developed after 1950. "Lois and her mother were legends to us," Ferguson says.

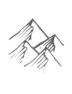

PART II
PIONEERS AND FARMERS

A Bed Warmer Provides the Link to an 1830s Winter

Winters were much colder two centuries ago. Rivers froze. In 1835 a four-horse wagon crossed the French Broad River on ice. Yet, despite the lack of such modern mainstays as central heating and supermarkets, Buncombe's pioneer residents, cheered by relief from farm work and by Christmas, found ways to luxuriate.

One symbol of early luxury was the brass and wood bed warmer, an example of which can be seen at the Zebulon Vance Birthplace in Reems Creek, thanks to the vigilance of collectors and curators. In the 1930s, a couple of decades before the North Carolina Department of Cultural Resources had acquired the Vance property, most of the family's early nineteenth-century family possessions had been sold to an antiques dealer. Since then, only a few of those artifacts have found their way back.

Not every family had a bed warmer. Most wrapped a heated brick in cloth and laid it between bed covers; or, lacking a brick, fetched a stone (avoiding river stones, which, infiltrated by moisture, might explode).

The Vances were perhaps in a better position than anyone in the county to have a bed warmer. Mira Vance, mother of Zebulon, North Carolina's future governor, was sister to Bedent and Zebulon Baird, the first merchants to bring a wagon of goods into the mountains. The Bairds made trips to Rutherfordton, North Carolina; Augusta, Georgia; and Charleston, South Carolina, and therefore had access to British manufacturers.

The china platter on display at the Vance Birthplace is remarkable not because it's a rare object, but because it would have been an extremely rare object in Buncombe County in 1800, when it had been owned by Zebulon's grandmother, Priscilla Brank Vance. In fact, the Vance cabin itself was a rarity, for its two floors flouted the lack of wood stoves and thus the winter cold that chilled every part of the house except for the areas by the fireplaces.

Dreading the trip upstairs at bedtime, little Zebulon, age five in 1835, could have looked forward to the bed warming ritual. The warmer's brass pan would have been filled with coals and then sprinkled with salt to keep down sulfurous smells. Its bearer would then pass it between bed sheets in a graceful arcing motion.

Part II: Pioneers and Farmers

The Vances provided their beds with goose down comforters and mattresses, a Scots-Irish preference. Kate Carter, program specialist at the Schiele Museum of Natural History in Gastonia, notes that it took fifteen pounds of goose down to fill a mattress. Consequently, the owners of such mattresses would have refreshed the stuffing infrequently and would have suffered with bugs, which probably accounts for the German preference for straw tick mattresses.

With the Vance dependence on down, one can imagine that their homestead was overrun with geese—and it isn't unlikely that little Zeb once frightened an old gander to death, as Ruth Szittya imagines in her biography *Man to Match the Mountains: The Childhood of Zebulon Baird Vance*. Animals of all kinds were vital to mountain farms.

Mice, Apples and Duels

In a brick in the Vance's sitting room fireplace, one can see an embedded turkey footprint; and in a kitchen fireplace brick, two cat-paw prints. The paw prints are reminders of the war against corn-eating mice. Better than housecats, however, were house black snakes, which reached into mouse habitats more easily than cats and which precluded the colonization of houses by poisonous snakes.

The turkey print evokes winter dinners and the march of turkeys, pigs and cattle along the Buncombe Turnpike, completed just a couple of years before Zebulon Vance's birth. A smooth, slanted groove in a corner brick in the Vances' kitchen fireplace indicates knife sharpening and elicits an image of the turkey's fate.

By 1835 Silas McDowell, Buncombe County tailor and pomologist, had begun to experiment with winter apple tree seedlings obtained from the Cherokee, thus freshening the mountaineers' winter diet. Pies, cider and apple-fed pigs would have become part of the family experience by the fire, where Grandma would have brought her wool spinning and Uncle his tale spinning.

Zebulon Vance may well have dipped into the large family library—most of which had been inherited from his uncle, Dr. Robert Vance, lottery winner and duel victim—in order to claim a corner of the hearth for his self-education. Only one volume of that library remains at the site—*The History of Redemption* by apocalyptic Puritan preacher Jonathan Edwards.

Edwards gave cause to the Vances to be wary of their riches for, as he admonished right at the start: "The moth shall eat them up like a garment, and the worm shall eat them like wool: but my righteousness shall be forever, and my navigation from generation to generation."

A Washboard
Tells a Story

Monday, wash day; Tuesday, ironing day; and so on through to Sunday, the day of rest. Once upon a time, not too long ago, many people ordered their work lives into daily rituals. They made such work the means by which youngsters were taught skills and initiated into adult society.

Hence, a washboard, such as the 160-year-old one preserved by the Cashiers Historical Society in the Zachary-Tolbert House Museum, tells a big story.

"When women come through the house today and look at that washboard, they shudder," says Jane Nardy, Cashiers historian and great-great grandniece of the home's builder, Mordecai Zachary. In the middle of the board, the chiseled ridges are far more worn down than they are on the edges, revealing the passage of knuckles as well as time and traditions.

"Over that washboard," says David Carr, UNC professor and author of *The Promise of Cultural Institutions*, "people transmitted stories and they transmitted the value of keeping clean against the odds."

You can bet, if an article of clothing or bedding made it to the washboard— after beating, spot-cleaning, boiling and rinsing—it must have been a dandy of a dirtying it had suffered. Either that or the clothing belonged to a fussy Lowcountry gentleman on vacation.

Every summer, Mordecai and his wife, Elvira Keener Zachary, moved out of their eight-room Greek Revival house to make room for the sportsmen coming up from Charleston. The Zachary women did the paying guests' washing, which often involved cottons rather than woolens.

The visiting elite did not expect or get a soft lifestyle. When the eminent statesman John C. Calhoun visited the Zacharys, he shared a bed. Smoke, dirt, blood and fish grime came home with the hunters on their clothes.

Stories must have been told when those cottons crossed the washboard. The gentlemen had not needed to worry as much as the mountain people about wearing out and replacing their clothing too quickly, and class observations must have been vented in humor and frustration against the rhythm of the board.

One of the first images that girl-initiates must have registered on Mondays was of hands: the skin of their delicate ones compared to those of their elders, roughened by freezing cold water and water boiled with lye soap. The

external change may have come at the time that the girls' bodies were changing internally, an event also marked, perhaps, by the use of the washboard on their own stained garments.

Counterbalancing the rigor of women's washing was the roughness of men's routines, indicated by the grease, grit and gore of butchering, sawmill work and veterinary work. The clothes told.

One thing that the Zachary washboard did not undergo is the washing of the blood of war. During the Civil War, the Zacharys, descendants of Surry County Quakers and Union sympathizers, moved to Elvira's family's place on the Qualla Boundary. The washboard stayed behind.

You Can't Take the Crockett out of Fairview

T he Fairview settlers who followed the wilderness path through the Swannanoa Gap to Cane Creek found that the promised land needed some amendment. It was swamp—wet, insect-infested and covered with grass as tall as a horse's shoulder. It had been where the region's once-dominant buffalo had roamed.

John Burton—Asheville's first developer—and other 1790s guys had bought hillside properties in Fairview until they got around to burning the grass, draining the swamp, laying down chestnut logs and creating pastures below. Burton's brother-in-law, William Forster II, did the same on a hill above Swannanoa River swampland, where the Biltmore Estate is now located.

It took about twenty years for Fairview's settlers to transform the landscape to improve farming and diminish the threat of typhoid fever, the era's number one killer. During that time, another generation had been born, and land had been sold and divided up, leaving few large, flat tracts for plantations.

With few plantations, slaves were scarce and farms served many purposes. Identification with the Confederacy wasn't as clear as it was in lowland places during the Civil War. The small farm legacy of the area resulted in a remarkable institution in the 1920s, as Fairview's farmers banded together to help form the Farmer's Federation, a cooperative designed to lower overhead expenses.

Fairview has also put a distinctive Appalachian stamp on history. Davy Crockett did a kind of stomp there. Crockett, Tennessee-born, married Elizabeth Patton and moved to her home territory in Swannanoa in 1816. By

this time, the traffic of settlers and farmers had begun to qualify as commerce. Davy and others, riding out one day, bumped up against a tollgate on the road through Ridgecrest. Their response to the toll road was to build a different road, without a toll.

In his June 1999 column "Days Gone By…In Fairview" in the *Fairview Town Crier*, Bruce Whitaker revealed that "Crockett and many other people were furious…[They] went out what is now Charlotte Highway [74A] to Fairview. About 1½ miles past Minehole Gap, they started clearing a bridle trail east to Old Fort." For a time after this, Old Fort Road was known as Davy Crockett's Bridle Trail.

While working on the road, Crockett stayed at the home of Whitaker's great-great-great-grandfather, William Whitaker. The house, built in 1800 and torn down around 1920, featured an eight-foot-wide fireplace that accommodated four-foot logs on one side and William's chair on the other. The hearth was the site of many stories, including family tales told repeatedly by women doing their handiwork. Bruce Whitaker had taken an interest in these stories when he'd returned home from college, having become acquainted with his ninety-year-old grandmother under his parents' care.

Young Whitaker began strolling around his neighborhood talking with dozens of elderly relations. His great-grandmother's sister, Narcissa Nicholson Rickman, had known and heard stories from her great-grandfather, John Nicholson, who had fought in the Revolutionary War.

The Validity of Oral History

Whitaker started publishing his columns in the *Fairview Town Crier* in May 1999, about the time that the state started widening Route 74A—the old Charlotte Highway—through Fairview. "Since I descend from, or am related to, all the old families of Fairview," Whitaker began, "the paper felt I might fill a void caused by lack of involvement of the older families in the newspaper."

Whitaker's article on Crockett had been his second entry, and it created some controversy. When Fairviewans petitioned the state to place a historical marker at Old Fort Road, where Crockett had put through his eastbound alternate to the Ridgecrest toll road, they collided with an academic roadblock.

The state's expert, Dr. Jerry Cross, did not find enough evidence to authenticate "Davy Crockett's Bridle Trail." Whitaker's rebuttals to Cross's concerns point out that there are various methods of establishing historical fact.

Cross asked: Why isn't there a record of the permission Crockett should have gotten to lay out a road? Whitaker's answer: Aside from the matter of Burke and Buncombe County courthouse fires, which had destroyed records, there was the tendency of mountain people to distrust and circumvent government.

Most disturbing to Whitaker was the official dismissal of oral history accounts (for instance concerning Crockett's time in Swannanoa) when oral history was all the mountain people had. Whitaker's talk with Eva Smart, one elderly neighbor, revealed her ability to describe and name every child in a 1904 Old Laurel Bluff Schoolhouse class photo. She was blind.

German Settlers

You can still catch glimpses of the little people called Hootnoggers on Piney Mountain in South Hominy, folks say, evoking the world of the German immigrants who settled there. Fleeing war and persecution in the Rhine Valley in the early eighteenth century, peace-loving Lutherans progressed from Pennsylvania to Rowan County and then to the Haywood-Buncombe County line in group moves over three generations.

Henry Miller, born in Northern Virginia, moved from Elk Shoals (now Hiddenite, North Carolina) to Dutch Cove (Haywood County) in the 1810s, carrying his sawmill equipment and a family of eight children. Community developers had hired Miller to clear and sell timber. He was at home in the woods.

Chip Miller, a South Hominy resident and Henry Miller's four-times-great-grandson, passes along family lore about the Hootnoggers. They were protective spirits of the woods who themselves deserved protection. "If you didn't eat your food or you didn't wear your clothes," Chip Miller relates, "my parents would say, 'We know where the Hootnoggers are. We can give them your clothing and food. They need to survive.'"

"Walking through the woods," says Miller, recalling his childhood in the years after World War II, "I heard a Hootnogger's whistle, I saw a smiley face in a log end." The shy sprites warned woodsmen about falling trees, too—a danger with which the Millers were familiar, for Henry Miller's fifteen-year old grandson, David Miller, had been killed by a felled tree.

Methodists, Midwives and Panthers

The Germans' wandering spirit did not stop in Dutch Cove. Henry Miller's son, Henry Miller Jr., crossed Smathers Mountain to marry Elizabeth Warren, whose father owned a gristmill in South Hominy. Other sons, Peter and John George, moved to West Asheville and established Miller Meeting House, which has become Trinity

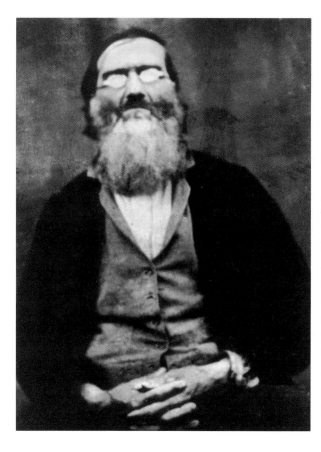

Henry Miller Jr. had crossed Smathers Mountain in the 1820s to marry Elizabeth Warren in South Hominy. By the time of this photo, Elizabeth had died and Henry had remarried, adding one child to the eight he had had with his first wife. The Millers and Warrens were early German and English settlers in Buncombe County. *Photo courtesy of Chip Miller.*

United Methodist Church. An early circuit-riding preacher had persuaded the Dutch Cove Lutherans to adopt Methodism and avail themselves of local pastors.

The Smathers Mountain area is a sacred site to Buncombe's early Germans, being the oft-traveled gateway to greener pastures. Champion Paper housing now covers much of the territory, obscuring landmarks but also contributing to the itinerant tradition. Christine Miller, who married Lloyd Willis "Bud" Miller, a four-times-great-grandson of Henry Sr., recalls a modern tale of mountain travel.

"My daddy, Jess Israel," she says, "when he worked at Champion, he walked across that mountain. It was four and a half miles to work and he hit the trail about 5:00 a.m. and didn't come home 'til dusk." She also recalls an older story—about a midwife who went to deliver a baby on the other side and whose disappearance was only explained by a panther's scream.

Sprung from a Creek-powered Mill

If you wanted to start a community in the wilderness in Buncombe County in the early nineteenth century, there'd be a few things you'd need—a mill, for one. Henry

Part II: Pioneers and Farmers

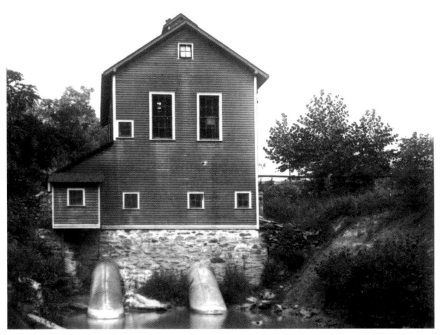

The Hominy power plant was run by a diesel engine and replaced a water-powered mill, which had been a mainstay in the area in the nineteenth century. In 1941 residents petitioned for an electric plant that would draw on Carolina Power and Light and meet the increasing demand for lights and appliances. *Photo courtesy of North Carolina Collection, Pack Memorial Library.*

Miller Jr., who crossed into South Hominy in the 1820s, wasn't a miller, but he married the daughter of one. Elizabeth Warren, his wife, was one of ten children of James Warren, owner of a grist and sawmill at the junction of Warren and South Hominy Creeks.

The creek's flow was so slight that the sawmill operator, when asked how things were going, joked, "the saw went up yesterday and I'm looking for it to come back down sometime today." By 1900 the Warren family was supplementing their waterpower with a diesel-fueled engine. Still, the old mill had been a big improvement over the pounding mill, an automatic contrivance by which pails of water lifted wooden blocks.

Originally, the Warren mill was creating enough of a surplus of cornmeal and walnut boards to take the goods to market. Warren's great-grandson, George Riley Warren, recalled in a 1941 *Asheville Citizen* article how in the 1860s he'd hauled lumber into Asheville by oxcart. "The distance was 15 miles, and I couldn't make it in one day, so I would camp out in the hills at night. At that time, there was nothing to Asheville but a few frame houses and hardly any traces of streets. There was a big need for lumber."

Courtship

Mostly, however, mills were local institutions. "Communities at that time," says Dr. Ken Israel, descendant of early Hominy Valley settlers, "weren't isolated, but they were self-contained. They had as many people living in them as did Asheville." Children shelled dried corn kept in cribs, carried a bushel on horseback to the mill and, while they waited, played. "Many times these children first met their future mates at the mill," Israel notes.

How Henry Miller Jr., of German ancestry, met Elizabeth Warren, of English descent, is unknown. It may have been at the mill or on the mountain ridges where the Millers had grazed their cattle or at a church picnic. New communities often formed along lines other than religion or national background. Two generations later, Millers and Warrens contributed land toward the formation of the Piney Mountain Methodist Church and two of Henry Jr.'s grandsons, Arthur and Herndon, established a store and kerosene-powered mill at the mouth of Morgan Branch.

Christine Israel Miller recalls waiting for corn to be ground at the Millers' mill. She preferred to go there on the weeks on which Arthur Miller presided, for he gave her treats and was the picture of the happy miller, found throughout German literature. "I sat on the store's front porch, waiting," she says. "Sometimes Uncle Arthur left at midday to take a nap, and when he returned, he'd be walking along, whistling and looking at the clouds."

Gravestone Tells Tale of Pioneer Religion

The most prominent gravestone in the Miller family graveyard in South Hominy is a monument that features on one side the name of Jeptha Miller, a German Methodist, and, on the other, Margaret Morgan, his wife, descendant of a conservative Baptist preacher. Perminter Morgan, Margaret's great-grandfather, founder of the Bethel Baptist Church in Rutherford County in the 1790s, was known to fall to his knees in farmers' fields and engage in fervent blessings of crops.

Margaret's great-uncle, Stephen, was even more active in wielding what he called "the Sword of the Spirit." Engaged in battling the Methodist Great Awakening in the early 1800s, Stephen Morgan founded the French Broad Baptist Association and blasted Methodism from the pulpit. Famous for his uncompromising sense of salvation and his disdain for infant baptism, Stephen Morgan often preached, "There are three things God Almighty never made and never intended should be: a mule, a mulatto and a Methodist."

In such an environment, how could a Miller-Morgan marriage come about? Dr. Ken Israel, a Morgan descendant, states, "When there's a shortage of men and women in the neighborhood, biology overrides religious beliefs."

Hangings and Individualism

Yet politics also played a part in binding the region's early settlers. German, Scots-Irish and English dissidents shared a hatred of authority that had extended from European civil wars to the Battle of Alamance. Christian Sargent Messer, an early German settler in Dutch Cove in Haywood County, had witnessed at age ten the hanging of his father, a captain in the Regulators' effort to overthrow the provincial government and its corrupt tax collectors.

At age 116, Messer's son, "Fed" Messer, was still entertaining Waynesville with tales of German hardiness and good humor. Regarding his disdain for dress codes, Fed used to say, "I've jist had my shirt buttoned twice in my life. That was once the time I got married to my ol' critter [his wife], and t'other time was on that cold Sattday...[when] if you threw up a glass of water, it would be ice before it hit the ground."

Many of the German settlers of Dutch Cove and Hominy Valley came from the North Carolina Piedmont, from which General Griffith Rutherford had recruited an army of 2,400 in 1776 to put down Indian raids in the mountains. Rutherford's men had turned up Hominy Creek after crossing the French Broad, no doubt leaving an impression of available farmland.

When the Millers arrived in Dutch Cove, they attended Nehemiah Bonham's Morning Star Lutheran Church, but soon Bishop Asbury's Methodist camp meetings attracted them, and they switched denominations without trouble. Jeptha Miller grew up in Buncombe County and was socially connected to his wife because both had grandparents in the sawmill business. His retention of his German heritage was reflected in part in his pacifism.

"He didn't believe in slaves and he didn't believe in carrying arms," says his great-grandson, Chip Miller, South Hominy resident. In the Civil War, Miller says, "Jeptha served as a messenger and transported medical supplies."

Farm-inspired Faith in West Asheville

Christine Miller is still searching for Peter Miller's Bible. Her genealogical odyssey with her husband Bud has not turned up the sacred object, carried by Bud's three-times-great uncle from South Hominy to West Asheville in 1847, when he established the Miller Meeting House, forerunner of the Trinity United Methodist Church on Haywood Road.

Yet history has preserved an 1855 class book from the meetinghouse. Listed therein are many Millers, first among whom are Peter Miller; his brother, John George Miller; and their wives, Elizabeth Alexander Miller and Anna Alexander Miller, sisters. The class book notes that members sometimes paid

tithes in tobacco and yarn. The Millers and the Alexanders came from German and Scots-Irish logging and agricultural families, who had settled in Buncombe County after having migrated from the Piedmont.

"Peter dressed in high style and drove a buggy around West Asheville," Christine Miller relates about the church founder's first forays there. "He was one of the few who wore a top hat." The good news he was bringing was education for the children of the community, which lay along the Western Turnpike from Salisbury. His meetinghouse was primarily a school and served additionally as a nondenominational place of worship.

Preaching

John George's son, George Miller, delivered the first sermon, it is thought—it was either he or John Reynolds, whose 1850s house still stands on Westwood Place. No record of their sermons survive, but a sermon delivered by Reverend Numa F. Reid of the Salisbury Circuit gives a good sense of the Methodists' emphasis on education and their appeal to country folk.

"In the physical world," Reid preached, "the laws by which all things were created and are regulated are founded in reason...So in religion...There is not a single principle inculcated that is not in strict accordance with reason."

He built up to a pitch that equated grace and damnation with the science of sowing and reaping: "As the seed deposited in the earth, under the influence of the atmosphere, and soil, and sun, and shower, will germinate, and grow, and mature, and produce a multiplied crop of its kind, so the seeds of truth or error, of proper or false training, dropped on the heart, sown in the spiritual world, will produce crops of their kind."

The mystery of the German Lutheran transition to Methodism in Haywood and Buncombe Counties is explained in part by German farmers' experiences of grace. Reverend James B. Finley's 1855 *Sketches of Western Methodism* records in dialect the experience of a "Dutchman" (Deutsch-man, or German), who fled from a Methodist prayer meeting, exclaiming to himself, "De devil vill git me!"

Running home, the German suffered inexplicable falls. The next morning—in the barn, thrown on his back under the horse trough—the afflicted man heard a voice say, "Di sins pe all vorgifen," and he felt something come over his head like honey. Then he hugged his gray horse, Pob, and shouted, "Glory, glory to mine Got!"

Hand-forged Nails and God in Cornfields

Examining pioneer history is like collecting pottery shards in a creek. It's hard to assemble whole objects. For instance, the settlers of Haywood County came from all directions, inspired by various promotions and stamped by different backgrounds.

General Griffith Rutherford led nearly three thousand men across the Ford of the Pigeon (present-day Canton) to a camp near Mount Prospect (Waynesville) in 1776 to prepare them for a scorched earth mission. The Cherokee, newly allied with the British, were attacking American families who had settled East Tennessee after the French and Indian War, and they had to be vanquished.

Among Rutherford's militiamen were Robert Love, son of landed aristocracy from Virginia, and Jacob Shook, son of a German immigrant. They were two of the earliest property owners in Haywood County, and they must have viewed their future landholdings with intensified awe while traveling with Rutherford.

Between the periodic destruction of thirty-six villages (involving slaughter, according to a few accounts), the troops marched long distances through autumnal woodlands and fields of abundant corn. The corn—the basis of Cherokee civilization and the gift of Selu—went up in flames before the avengers' torches.

It had been corn paradise in Haywood County and Tennessee, the setting for what would become hog paradise and the building of the era's superhighways: livestock turnpikes. No wonder that Jacob Shook, decades after his traumatic experience with the Cherokee—after he had built a house with hand-sawn timber and hand-forged nails and after he'd played host to Methodist Bishop Francis Asbury—experienced a conversion in a cornfield.

Reverend T.F. Glenn wrote of Shook, "Whilst under conviction for sin he went into the cornfield to plow. He prayed and he wept as he worked. Finally the burden of sin was lifted and his soul was flooded with joy. He…shouted all over the field."

The Pennsylvania Dutch, whose families had found their way to Canton and Dutch Cove, were a mystical and devout, land-loving bunch. They were only one element.

There were other elements, including gentry. Robert Love, the founder of Waynesville, and Haywood County's largest resident landholder in the early 1800s, could trace his lineage back to William the Conqueror. "Love" is an Anglicized version of the name "Wolf," changed to "Luiff" in Scotland, where the family had migrated.

When you think of Robert Love, think of George Washington: a surveyor, speculator, soldier, gentleman farmer, slave owner, horseman and dandy. "As a very wealthy and influential man," a Love genealogist writes, "he had worn a powdered wig on formal occasions in his earlier years, and he maintained his old-fashioned attire, except for the wig, after fashions changed, wearing a blue swallow-tail and knee britches with silver knee buckles and silk stockings."

Haywood County in 1810 was a place where the most common store-bought items were saddles, lead, cotton cards, steel and flint. Knee buckles were a rarity.

The History of Haw Creek

L ittle would modern visitors know that, while attending a movie at Beaucatcher Cinemas on Tunnel Road, they were standing on the former site of the old Haw Creek School and that the school once stood at the head of a farming community with a distinct identity. Driving down New Haw Creek Road, off Route 70, past Haw Creek Mews—a 294-unit apartment complex built in 1991 despite local opposition—a visitor might find it hard to imagine that just around the bend stood Miller's Store, formerly east Buncombe's downtown.

On Saturdays, farmers from Haw Creek, Chunn's Cove, Riceville, Grassy Branch and Bee Tree used to visit Noah Miller's grocery and feed store (occupied in 2000 by Dalton Carpet Outlet, a defunct Ice Service store and a carpet warehouse) to buy supplies and talk about their concerns. "It was the retail and cultural center of east Buncombe," says Alan Carscaddon, a Haw Creek native who'd worked at the store as a boy. "A dozen men would always be there talking about the weather, the crops, and the war in Europe."

Not much farther down New Haw Creek Road in Carscaddon's day, the paving laid down at the onset of the Great Depression had stopped, state funding having dried up. Until the 1970s, Haw Creek was still very much country. In 2001, Beatrice Creasman, a strong eighty-six-year-old farmwoman who lived her whole life at the head of one of Haw Creek's feeder streams, recalled having very little leisure during her country childhood.

"My favorite thing was feeding the chickens," Creasman said. "They were almost like pets. I'd go to the chicken house at 7:00 a.m., and they would all come to me

Part II: Pioneers and Farmers

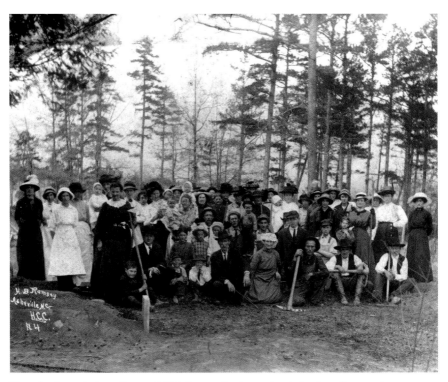

Haw Creek residents gather in 1904, hoes and rakes in hand, to clean the cemetery at Bethesda Methodist Church. In the front row, first on the left, is young Theodore Creasman. Noah Miller's brother, Will, who ran the feed store, is third from the right in the front row. *Photo by H.B. Ramsey, courtesy of Tim Rhodes.*

and look up at me, waiting." Breakfast followed. It consisted of eggs that she had just gathered.

Beatrice's mother, Annie Ethel Bartlette Creasman, worked equally hard and found solace in her milk cow, which would only respond to her. Beatrice's brother, Theodore Creasman, supported himself doing odd jobs in fields and at the Antioch Christian Church. Beatrice's father, John Baxter Creasman, had managed to acquire the family's thirty-one acres by working off the $900 price on John Berghouser's poultry farm.

Aside from jaunts to Miller's store, Haw Creek's industrious inhabitants sought release in the community's schools and churches. Before the old Haw Creek School, established in 1922, children had attended a schoolhouse funded by Asheville's Episcopal Church and run by a circuit-riding preacher named George Bell. Bell reinforced his fellow Haw Creekers' stern view of life's demands, keeping five or six black gum switches behind his desk for disciplining purposes, according to the memoirs of Robert Reese, whose grandmother, Penelope White, had married Bell after her first husband's death.

Bell was fluent in seven languages and had connections in New York that had brought barrels of toys and Christmastime candy into Haw Creek, Alan Carscaddon recounts. At the same time, Bell was remembered as a preacher who was often on a horse and generally muddy. Many couples and new parents waited days for his blessings and sacraments.

In addition to Bell's Trinity Chapel, the Bethesda Methodist Church and the Antioch Christian Church served the community. Although dancing was not allowed, music flowed through every working and worshipful moment in Haw Creek. Nola Mae Allen Rhew remembers how when she was twelve, the Antioch Christian Church community recognized her natural piano-playing abilities and enlisted her for a variety of events, including Robert Baker's funeral. She vividly remembers the deceased's granddaughter, little Joanne Gwen, crying in the first row only a couple of feet from where the piano had been situated.

Religion was an intense experience. Theodore Creasman came to Antioch Church every Sunday—sometimes with a supporting quartet—to lead the singing of a single hymn, the same every time, "Jesus, Lover of My Soul." Mae Allen had to slow down or speed up her playing depending on whether she wanted to accompany the voices of the congregation or of Creasman, who was often a good-spirited half-beat behind.

Shape note singers, practitioners of a unique Southern Appalachian choral form, sometimes stayed at the home of Robert Reese's father, Burgin Reese. Haw Creek folks came to them for lessons. It no doubt affected the tenor of the Reeses' church, Bethesda Methodist, where, according to Robert Reese, one man became so enamored of salvation, he climbed a tree to jump into his Savior's arms.

Haw Creek had been a tight-knit community, old residents affirm. The churches brought people together. In the fields, Haw Creek folks depended on themselves and each other. Outside labor was never engaged.

A look at the Reese family genealogy shows a complicated network of relations. For instance, Robert Reese's grandmother, Lucinda Cordell Reese, is also grandmother to Beatrice Creasman through her second husband.

Marriages rarely happened between Haw Creek families, but when Haw Creek family members married outside, they often brought their spouses in. Robert Reese had been accompanying his father to Franklin on a bridge-building project when he met their host's daughter, Sue Hunnicutt. She was beautiful, she baked excellent biscuits and she played the violin, Reese noted. What else could the man do but marry her and take her home?

Pure Country

Bears come down off the Blue Ridge Parkway these days, nosing around Haw Creek backyards just a jog away from new housing developments that have

Part II: Pioneers and Farmers

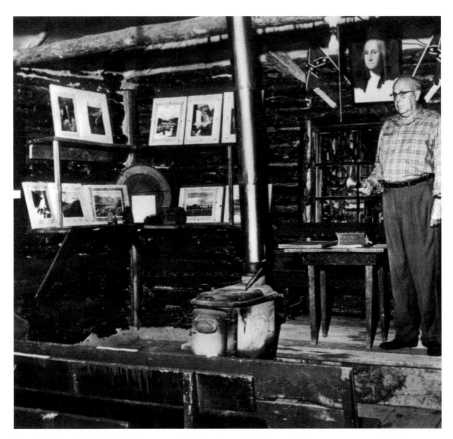

Frank Mann had Bob Masters construct a log cabin to replicate a one-room schoolhouse at which he'd once taught. The replica stood at the head of Haw Creek and served as a museum. *Photo courtesy of Richard and Kathy Fornoff.*

caused zoning battles in some cases. Droughts, as well as the lure of raccoon-style dinners, have impelled the bears to shed their shy ways. Droughts have also altered the look of Haw Creek itself.

Charlene Noblett, a lifetime Haw Creek resident, recalls that the creek by her house on Maple Drive "was once so furious and big that kids dammed it up and made a swimming hole six feet wide by twenty feet long by five feet deep." The water was cold. Children baptized in the flow behind Antioch Christian Church used to come out shivering, Noblett recalls.

Now, Noblett has had to have the creek in her pasture dug deeper (silt from development has compounded the drying up problem) in order to enable her cattle to drink. Her cattle maintain the agricultural status of her property and save her from being taxed residential, she says.

Through the 1980s, Noblett's part of Haw Creek had been able to escape city annexation because of low population density. Then a neighbor, Baxter Hahn,

felt he had to break his pact with Noblett's father, Rory Masters, regarding not selling his land. The Hahn place was broken up and became the subdivisions Trapper's Run and Huntington Chase. Annexation followed.

When Charles Speed, an Evanston, Illinois retiree, bought the Foster A. Sondley estate at the headwaters of Haw Creek in 1939, he noted, "The water supply is panning out far beyond my expectations and the University of Kentucky tells me that the water used for house purposes is equal in every way to distilled water…One spring gives me about 4,000 gallons a day."

Sondley, author of *A History of Buncombe County* and owner of a famously vast library, built his Haw Creek house in 1902 on property that gave him privacy in all directions. He was one of a handful of residents in the cove who formed a tobacco, corn, produce and livestock-farming community that lasted up through the 1960s.

"It was pure country," Harry Burnette, a Haw Creek native, says, referring to the remoteness of the place as well as to the closeness of the people. Rory Masters used to say, "If you put a ten dollar bill in a hat and put the hat on the road, someone would come by, recognize the hat and return it with the money." It's the same road on which "you could lay down for half an hour and nobody would come by," as Burnette tells it.

The physically remote but internally close community—centered on Bethesda Methodist Church and N.A. Miller's store—necessarily embraced eccentrics. Sondley, an erudite eccentric, was appreciated for his hospitality as well as his high culture.

In an interview that Erin Fornoff conducted for her high school senior exit project in 1999, Burdette recalled that when Sondley was asked by a neighbor to borrow a tool, he'd ask for how long. "You'd tell him three days," Burdette said, and Sondley would say, "You *shall* have it three days." At the end of the loan period, you'd ask to use it another day, and Sondley would pronounce, "You *shall* have it another day."

Fornoff's folks live at the head of a different arm of Haw Creek from Sondley's—off Mann Road. The road was named after Frank Mann, a retired Buncombe County schoolteacher who established himself in the woods in the 1950s and had Rory Master's brother, Bob, build him two replicas of the log cabin in which he'd once taught. In one, he established a one-room schoolhouse museum, which the children loved to visit. Residents remember Mann driving to market dressed in a suit and top hat, sitting in a straight-back chair nailed to an old two-horse wagon.

Much of the Haw Creek wilderness above the topmost homes survives, although you won't find a mountain lion attacking your cow, as Ab Owen once did; and you won't go hunting in the fox-populated hills, as Robert Reese did with his father, who owned fifteen hounds; and you won't even find the black snakes

and copperheads as pesky as they once were, as when Charlene Noblett's mother, Hazel Masters, encountered a black snake in her daughter's crib room.

Haw Creek residents can look backward, if they wish, or upward, as did Noblett's grandfather, James Davis, when he came to Haw Creek from Madison County to recuperate from an illness in the 1930s. He'd sit in a chair in the yard and look up at Cedar Cliff. He'd watch the federal workers dynamite the mountains for the Blue Ridge Parkway and occasionally see the snakes scattering.

PART III
THE CIVIL WAR

How Unionist Were
Mountain People?

S tories about the Civil War in Western North Carolina provoke a debate. Was Western North Carolina surprisingly Confederate or Unionist in sentiment? To what extent was slavery a presence in the region and to what extent was it a cause of the war?

Richard D. Starnes (in "'The Stirring Strains of Dixie': The Civil War and Southern Identity in Haywood County, North Carolina," published in *The North Carolina Historical Review*, July 1997) indicates that in 1860, 313 slaves lived among 6,000 white residents in Haywood County. In Madison County, notes Philip Shaw Paludan (in *Victims: A True Story of the Civil War*), there were 46 Madison County slaveholders and 213 slaves. John C. Inscoe and Gordon B. McKinney (in *The Heart of Confederate Appalachia: Western North Carolina in the Civil War*) record that, in the seventeen westernmost counties, 10.3 percent of heads of households owned slaves.

All counts seem to confirm that mountaineers were less dependent on slavery than were other Southerners. But does believing in slavery require owning slaves?

Starnes stresses that Western North Carolina had strong commercial and cultural ties with South Carolina and Georgia, and that when planters made summer visits, their attitudes and those of their slaves influenced mountaineers.

That's one thread. Here's another.

Mountain farmers and businessmen depended a good deal on white laborers and tenant farmers, who were subject to see slavery as a threat to white labor. Yet it may be as Inscoe says, that mountain society was politically led by its slaveholding elite who were able to forge public opinion. Abolitionism was not as apparent in Western North Carolina as it was in East Tennessee.

Didn't Confederate enlistments greatly outnumber Union enlistments in the region?

There were 20,000 Confederate enlistments, says Starnes. Union enlistments totaled 4,500, says Paludan. Terrell Garren, the first historian to do an exhaustive count of existing enlistment records, figures only 1,836 Union enlistments.

It all depends on what you count and when you count. Though Garren's methods are the most conclusive, the questions still remain: Why did Western North Carolinians join the Confederacy in such high numbers in 1861 and 1862? What was actually in individual solders' minds? And did those minds change over time?

Part III: The Civil War

The gravestone of William J.M. Cathey, killed at the Battle of Petersburg, stands in the Bethel Presbyterian cemetery (near Cold Mountain), flanked by the current Confederate flag and the original Confederate flag, which was replaced in 1863 because of its confusion on the battlefield with the Union's Stars and Stripes. *Photo by Henry Neufeld.*

Regardless of complexities, Southern loyalty was fervent and rampant in Western North Carolina from the moment Lincoln called for troops after the firing on Fort Sumter. Some historians have compared it to the mood after Pearl Harbor and 9/11.

Inscoe cites historian Samuel A'Court Ashe in saying that one in fifteen mountaineers volunteered for Confederate service by November 1861 as opposed to one in nineteen who volunteered from the rest of the state. Inscoe elaborates. A great majority of the first year's enlistments were young, single men who joined companies that were able to raise money for their provisions.

Why was Southern pride in the mountains so intense when mountaineers had had a long-standing power struggle with and distrust of Eastern elites? Paludan draws on a heated cause—rumors that Lincoln was intending to unleash a racial revolution.

Once the war proceeded, other factors affected Confederate and Unionist feelings. Disillusionment with the cause and the impetus for family survival led to disenchantment with the Confederacy, though not necessarily enchantment with the Union. War settlements altered declarations of loyalty. If you'd ever wavered, proof of Unionist sentiment could get you some reparations.

When Reconstruction passed, educators revised history. Civil War veterans established societies that aided Confederate families and commemorated the war. The United Daughters of the Confederacy supplied a Southern perspective to classroom history, stressing the themes of legality, bravery and states' rights.

A Henderson County Perspective

The widely held belief that most Western North Carolina counties had been primarily Unionist in sentiment is dispersing like fill from an archaeological dig. Terrell Garren, a descendant of three Henderson County Confederate soldiers, admits, "My own parents told me this was nearly half-Union country." His research over nearly two decades has shown otherwise.

Via Garren's ancestry, we visit Calvary Episcopal Church in Fletcher, July 15, 1861, where Williamson Garren, age twenty-eight, had enlisted. Mimi and Daniel Blake had organized a barbecue and provided the funds to pay each soldier an advance of ten dollars. The recruits elected their captain, choosing the Blakes' young son, Frederick, to head Company H of the Twenty-fifth Regiment.

In the church crowd stood Solomon Cunningham, private and thirty-five-year-old father of a large family. Cunningham was one of more than twenty thousand Western North Carolinians to join the Confederate troops, which some scholars say outnumbered Union recruits in the region fifteen to one. Garland Ferguson, a Company F veteran, noted in Walter Clark's *Histories of the Several Regiments and Battalions from North Carolina* that "the majority of the men composing the regiment had been Union men until after President Lincoln's Proclamation," when they acknowledged their Southern allegiance and "had gone to war to defend their homes from invasion by an armed foe."

When the Twenty-fifth joined General Robert Ransom's Brigade and headed into Northern territory in late June 1862, the soldiers' purpose began to splinter, for some felt they were no longer defending their homeland. The slaughter that the brigade underwent at the Battle of Malvern Hill, where the Twenty-fifth came within twenty yards of their enemy on July 1, further demoralized the troops, acutely aware of their families' sufferings back home.

Most of Cunningham's friends were killed at Malvern Hill. Williamson Garren lost first cousins. Cunningham himself was wounded and survived to meet his end

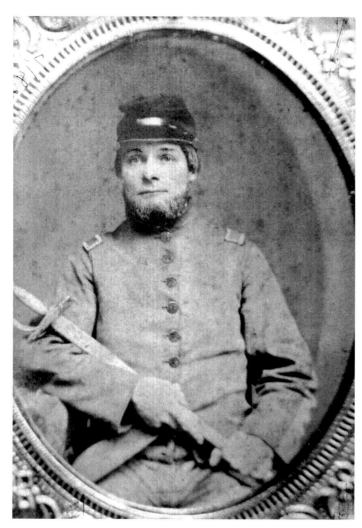

Solomon Cunningham, pictured in 1862, died at the Battle of Fredericksburg and was survived by his wife, Sarah Saphrona Fletcher Cunningham. *Photo courtesy of Noni Dillinger.*

at the Battle of Fredericksburg on December 13. At the time of Malvern Hill, the Sixty-fourth Regiment was organizing in Madison County—eight months before the Conscription Act—to address vicious struggles over mountain passes.

Cunningham's death left his widow, Saphrona, to raise their children, one of whom, George Cunningham (born 1855), grew up into a man of hot temper. In 1874, in a teamster's camp in Swannanoa, he murdered Daniel Sternberg, presumably in self-defense when Sternberg violently refused to yield his money after a night of card-playing losses. In Madison County, Cunningham was tried, sentenced and hanged—or so some think. Others have said that the hanging and subsequent burial had been faked. His family's exhumation of his coffin in 1959 turned up no bones, but only the remains of a large oak log.

The Civil War
Is Waged in Print

In August 2001, Connie Ward, self-named "perpetrator" of the website *180 Degrees True South*, wrote regarding the War of Secession, "The only thing that was over and done with a century and a half ago was the shooting." Ward listed her home as Pensacola, Florida, Confederate States of America, and gained regional significance by having taken on Stephen M. Black, columnist for the *Hendersonville Times-News*.

Black had written an op-ed responding to a letter writer whom he'd called a "neo-Confederate gadfly." He had admitted, "As a Southerner (in Hendersonville), I grew up surrounded by myths and legends about the South." He called for a truthful representation of the Confederacy.

Consequently, Black wrote a five-part series on Civil War Union sentiment in Western North Carolina for the *Times-News*, bandying about facts in dispute. The controversy that has ensued relates to historical pertinence. Has the Civil War not ended in spirit? (I am using the most common term for the war although many will point out that the Confederacy sought legal secession from the Union, not an illegal overthrow of it.) Was Western North Carolina primarily Union at heart? How does it matter?

Black stated that 5,790 men escaped from twenty-one North Carolina mountain counties to Union lines during the Civil War. He also stated that Henderson County officials corrupted the local vote for Secession by forcibly excluding pro-Unionists. Both of these claims can be traced, through various second-hand accounts, to one original source: the campaign biography of Alexander Hamilton Jones, a Henderson County Unionist who was elected U.S. Congressman in 1868.

Although Jones moderated for forgiveness of Confederate citizens after the war and sought economic prosperity for the South, he also fanned the flames of antagonism by asserting that the Confederacy was a latter-day attempt by South Carolina Tories to address Revolutionary War losses. His count of Union soldiers in the area carries with it no documentation and is not corroborated by official rosters.

Black asserts that Wilkes County "was practically all Union." However, *North Carolina Troops, 1861–1865* names 1,570 Confederate troops raised from Wilkes County. Terrell Garren, counting Union soldiers for whom Wilkes County was recorded as home in enlistment documents and company records, came up with 145 wearing blue.

Part III: The Civil War

Pat McNeil, Camp Commander of the General James B. Gordon Camp of the Sons of Confederate Veterans has twelve Wilkes County ancestors who'd fought for the Confederacy, one for the Union. His survey of Wilkes County cemeteries shows a six-to-one ratio of Confederate to Union soldier graves.

As Garren notes, "on April 1, 1861, Western North Carolina was mostly Union in sentiment. On April 15, 1861, after Lincoln called for troops, it was 99% Confederate."

By early 1864, desertions and anti-Confederate sentiment increased, but Union sentiment was still spotty; and by January 1865, loyalties were compounded by tiredness, bitterness, pragmatism and opportunism.

Fiction, Fact and Factions

It appears that oft-repeated statements about Western North Carolina's Civil War loyalties rest not on a count of soldiers, but on Jones's pro-Union biography. Historians who say that 5,790 men from this region enlisted in the Union army are quoting him, knowingly or unknowingly.

Jones's reckoning was, he wrote, "from actual calculation," but he tells nothing of his method. His book, *Knocking at the Door: Alex H. Jones: Member-Elect to Congress: His Course before the War, during the War, and after the War—Adventures and Escapes*, reads as if Davy Crockett had written *Cold Mountain*. (Crockett's tall tale autobiography had been campaign literature, too.)

On August 30, 1863, Jones relates, he departed Hendersonville to meet Union generals at Knoxville and, while heading back, was captured through a betrayal. "I alone bore the fetter to Asheville jail," he writes.

Through prison bars, he saw the hills where he was born, six miles off and where his parents were buried. "Could they appear and hail to me, and ask, 'What are you doing there?' it consoles me to know that I could have answered, 'I am here for the love of that which you taught me to reverence next to my God—my Union.'"

Jones's odyssey, by his account, proceeded from Asheville to Richmond, Virginia, and from prisons to hospitals. Late in 1863 the Confederate army, needing soldiers, enlisted Jones to fight for its cause while under guard. Jones managed to escape by joining a Union squad marching past his regiment's camp in New Market, Tennessee.

Outfitted with a map of Virginia that his wife had mailed him and hampered by starvation and frostbite, Jones arrived in Maryland and within Union protection. Soon, he was sent back home where he was nominated to sit in the convention determining the fate of Confederates. He was also elected to Congress for a seat that could not be filled due to North Carolina's disorganization.

Jones was "knocking at the door," as he indicated by the title of his 1866 book, the publication of which apparently opened it for him. In 1866 he was opposed by three candidates—including Confederate Colonel James Robert Love, unelectable

because of his allegiance—who together garnered five votes to his every three In 1868 North Carolina was readmitted to representation, Jones got another chance, won and went to Washington.

Given the purpose of Jones's biography, it is hard to know what to believe. Jones's family had been well established in the region. The grave of his grandfather, Joshua Jones, retains its gravestone on Biltmore Estate property. Secure in his convictions, Alex Jones had freed his slaves. Yet, he became snagged in a crossfire of exaggerations and accusations.

One of his more intriguing and perhaps believable proofs of Union sentiment in the region comes inadvertently from his narrative of escape. Four times on his journey, he desperately and randomly chose houses to visit, and four times he received sympathetic aid. Of course, it was the end of the war, nearly everyone was sympathetic to those who hurt, and the houses were run by women.

The Cold Mountain Spotlight

The Home Guard and Deserters

Because Charles Frazier's work of fiction *Cold Mountain* has become a history lesson for many, it is important to let non-fiction supply some footnotes.

First off, there's the matter of the Home Guard. It would have been unusual to have seen them going around in isolated bands killing deserters in Western North Carolina during the Civil War. Their charge was to defend their home territory. When involved in enforcing conscription laws, they did so as adjuncts to detachments of the Confederate army.

Furthermore, it was the goal of conscription agents to capture and return deserters to the army. For such service, they received bounty payments.

Terrell Garren, an expert on the war in Western North Carolina, had several ancestors involved in the conflict. Two great-grandfathers—Joseph Youngblood and Williamson Garren—fought in the regiment in which Frazier's hero, Inman, fought, the North Carolina Twenty-fifth.

A great-great-uncle, Lieutenant Henry Garren of the Thirty-fifth North Carolina infantry regiment, led a detachment that aimed to talk deserters into returning to battle. His target was his home, Henderson County, where he knew who was who.

Part III: The Civil War

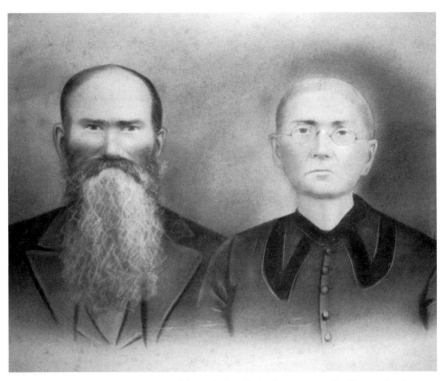

James Anderson Inman and his wife, Mary "Polly" Kirby Inman, were brother and sister-in-law to William Pinkney Inman, the Confederate private whose exploits inspired the novel *Cold Mountain*. Anderson had survived Camp Douglas, where two other brothers, Logan and Joseph, had died as prisoners of war. He wrote home, urging his wife to make use of his vast library of religious books to keep their children on the right path. *Photo courtesy of Rose Pless Case.*

"There is a lot more deserters than there is militia here," Serepta Revis of Henderson wrote on June 7, 1863. "Lt. Garren came after them and got half of them to go back...[He] went after Ruben and Ambrose Staton and one of them shot Garren and killed him...Then the men that was with him...shot at Rube and Ambrose and wounded them."

By 1864 the attitude toward deserters had changed, there being so many. Inman, coming home at this time, would not have had to so greatly fear retribution. Even if he had been captured, his serious wound would have recommended him for leave.

Regarding the Inman-Ada love story, in truth there might have been a wee bit less loneliness. As part of the Twenty-fifth Regiment, Inman would have spent some time in Hot Springs. A mid-war visit home would have been likely.

"James R. Payne, my wife's great-great-grandfather," Garren says, "was a private in the 3rd N.C. Mounted Infantry of the Union Army. He managed to get home and sire a child every winter during the war."

Details aside, the most significant variance from reality in *Cold Mountain* is its main focus. Inman's walk home perhaps makes a better story than the actual soldiers' test of endurance—their three-year succession of horrific battles and miserable camps. The representative story of Western North Carolinians in the Civil War would need to dwell on the worst day of death in the region's history, the battle of Malvern Hill.

All told, half of the North Carolina Twenty-fifth Infantry perished, 220 in battle and 280 from disease; and 470 suffered serious wounds. Like Inman, Williamson Garren survived Malvern Hill and was wounded in battle. But unlike Inman, Garren returned to battle and, after the war, received a Confederate pension, living with a physical disability and the deeper wounds that war bestows on its front-line veterans.

Inman Didn't Die?

William P. Inman, the real-life Haywood County Confederate soldier wounded in the neck at Petersburg, may not have, like his *Cold Mountain* fictional counterpart, died during the Civil War. This is said with great reservation since family oral history establishes William's wartime death.

Records show that, after Inman had deserted from a military hospital in Raleigh, he "went over to the enemy on an unspecified date and took the oath of allegiance [to the Union] in east Tennessee, December 1864." The source for this information could not be more authoritative—the rosters of the North Carolina Twenty-fifth Regiment, of which Private Inman had been a member.

We know the Inman of *Cold Mountain* had been in the Twenty-fifth because of many corroborating accounts, including this notation by Garland Ferguson, the regimental historian, about the hand-to-hand fighting at the Battle of Petersburg: "One 16-year old boy had his gun knocked out of his hands and picked up a cartridge box and fought with that."

Cold Mountain author Charles Frazier writes, "Inman saw one little drummer boy beating a man's head in with an ammunition box."

Here's another revelation. The departure from the Raleigh hospital had not been the first time that the historical Inman had deserted. The regimental roster notes that he had first done so about two years earlier, on September 5, 1862—a most significant date, for that was when General Lee's Army of Northern Virginia had started marching toward Antietam.

Ferguson observed, "When it was first made known to the men by General Lee's order that the army was to cross the Potomac, there was a considerable murmur of disappointment in ranks. The men said they had volunteered to resist invasion and not to invade."

After a two-and-a-half-month hiatus, Inman returned to duty, again on a significant date, November 19, 1862, as his regiment under General Matt Ransom's

Part III: The Civil War

These unmarked graves in the Bethel Presbyterian cemetery are some of many dating back to the Civil War. William P. Inman, on whose life and death *Cold Mountain* is based, is buried in an unmarked grave there, family history attests. *Photo by Henry Neufeld.*

brigade and General James Longstreet's First Army Corps positioned themselves above Fredericksburg. What had led Inman to rejoin just in time for one of the two horrific battles portrayed in *Cold Mountain* is a matter of speculation.

In certain cases, Confederate commanders issued amnesties or pardons to deserters who agreed to return to duty. Sometimes the reinstated soldiers were kept under close watch or under guard. Often, some sources attest, the returned deserters were placed in the most dangerous positions on the front line.

The battles of Fredericksburg and Petersburg form key elements in fictional Inman's story, yet there are other battles that could have figured prominently. The real-life Inman had been wounded at Malvern Hill, a supremely deadly battle, and had suffered through a seemingly endless succession of slaughters, including one desperate confrontation at Warm Springs (now Hot Springs, Madison County) in October 1863.

"A detachment of the regiment under Lt. Col. Bryson," the Twenty-fifth North Carolina history reports, marched from Garysburg to Warm Springs, where the enemy outnumbered them twenty to one. "The loss of the detachment in killed and wounded was heavy."

The Supremacy of Family Lore

If William Pingree "Pinkney" Inman, the soldier after whom Charles Frazier patterned his *Cold Mountain* hero, hadn't died during the Civil War, then what had happened to him?

Confederate muster rolls show Inman making an oath of allegiance to the Union Army in December 1864. Did he then leave the region or did he return to meet his death?

Inman family accounts attest that Inman had indeed been shot, along with his brother-in-law, John Swanger, by Confederates in a skirmish on Big Stomp about 1864. According to two sources—Tom Erwin, a preacher in the Inmans' community, and Ted Darrell Inman, a descendant and family historian—Pinkney's father, Joshua, had retrieved the bodies and buried them on a hill in Bethel Cemetery.

Unfortunately, no marked gravestones confirm this account, but Ted Darrell heard it from his father, Willis Ted Inman, who had heard it directly from both Pinkney Inman's sister-in-law, Mary Kirby Inman, and his own father, Ballew Inman, who had carried mail past the site of the shooting three times a week. Could such a memory be wrong?

Family lore is a critical and often reliable source of history in this region where families are close and the transmission of heritage is a kind of sacrament. Yet, how does the lore square with the record on Pinkney's oath of allegiance? A few theories emerge.

Inman might have returned to Haywood County in a Union uniform, and the date of his death might have been Christmas 1864, or some time in 1865.

When Inman's brother, Anderson Inman, had been released from Camp Douglas, Illinois, the prisoner of war made an oath of allegiance to the Union, Ted Darrell says. He then worked as a cooper and contractor in Boston, where he was associated as a minister with Universalist Church headquarters. Returning home, he wore a Union uniform with $3,000 in gold sewn into the lapels.

In a Union uniform, Pinkney could have been shot by the Home Guard rather than by a Confederate detachment, which would account for the lack of a Confederate record of his death. The alternate story—that he escaped impoundment by the Union army in order to return home—is less likely.

Ted Darrell strongly contradicts a third theory—that Pinkney's burial had been faked to enable him to escape retribution—even though it had been a practice elsewhere. George Cunningham, son of a Confederate killed at Fredericksburg, was supposedly hanged in 1874 after murdering a man at a teamster's camp in Swannanoa. The family felt that Cunningham had murdered in self-defense and descendants exhumed his coffin in 1959 to find not bones but an oak log.

"I'm telling you Pinkney Inman is buried in the ground," Ted Darrell says with a sure knowledge of his heritage. "There's too many family members who say so."

The Shelton Laurel Massacre
Another Story with Multiple Accounts

On January 19, 1863, a Confederate regiment headed by Lieutenant Colonel James Keith executed thirteen Shelton Laurel men, ages thirteen to fifty-six, for suspicion of Union sympathies and the theft of precious salt and meat from a Marshall storehouse. Memorialized as the Shelton Laurel Massacre, the event stands out as one of the most notorious in this region's history. Now, here's the rest of the story.

The battle over salted meat and the massacre were the explosive climaxes to months of antagonism and treachery in Madison County. Shelton Laurel, named after the Shelton family, 1790s settlers, had become a mountain stronghold and refuge for independent men refusing to serve in the Sixty-fourth North Carolina Regiment. From East Tennessee—a bitterly contested crossroads and breadbasket—Daniel Fry, a noted guerilla fighter and bridge burner, had come to Shelton Laurel to hide out and set up headquarters.

Nine months before the massacre, the *Official Records of the War Between the States* notes that the Forty-third Tennessee Regiment had been fired on by small bands of men in Shelton Laurel and that retaliatory firing had killed fifteen of them. "There seems to be a regular organization among the inhabitants," the report comments. "The whole population is openly hostile to our cause."

At the January 1862 North Carolina State Convention, William Hicks of Haywood County proposed that a battalion stationed in Buncombe County march into Shelton Laurel to round up disloyal citizens, seize their property, imprison them and treat them "as alien enemies." The ordinance seems to have never been passed.

On the day after the January 19 massacre, Brigadier General Henry Heth, commander of the East Tennessee Confederate Division, passed on to North Carolina Governor Zebulon Vance the following report from Brigadier General W.G.M. Davis: "I am satisfied there is no organization in the mountains of armed men banded together for the purpose of making efforts to destroy bridges or burn towns…I think the attack on Marshall was gotten to obtain salt, for want of which there is great suffering in the mountains…Col. Allen's 64th N.C. Regiment and the men of his command are said to have been hostile to the Laurel men and they to the former for a long time."

The Sixty-fourth had been forcing captured Madison County men into service. Stationed in East Tennessee, these men found it easy to desert. Five of the men executed at Shelton Laurel had been identified as deserters. The *Official Record*, for instance, notes that Halen Moore had taken a long sick furlough in 1862, had exceeded his time and had been declared a deserter on December 17.

"People in Shelton Laurel moved there to get away from government," notes Dan Slagle, a genealogist who turned to researching the human side of the Civil War in Madison County when he discovered that three of his great-great-grandfathers had served in the Sixty-fourth Regiment. The more he researches, the more questions arise.

Is There Any Way to Settle Questions of History?

On August 10, 2005, Mars Hill College's Southern Appalachian Repertory Company presented the premiere performance of Sean O'Leary's commissioned play, *Shelton Laurel*. The play attempted to resolve a chorus of interpretations and facts about the Civil War massacre by letting several characters express their points of view. "There's great disagreement as to what had happened," said managing director Deborah Austin.

O'Leary, Austin reported, faced such questions as: Were the civilians murdered by Confederate militia, or were they traitors executed for crimes against the Confederacy? Did the locals' raid on salt stores get out of hand as homes were ransacked for more than basic necessities? Was Colonel Lawrence Allen's revenge for the death of his children, ill and traumatized in the raid, a motive for the reprisal?

In O'Leary's imagined scenario, the year is 1894, and the setting is the back of a church in Marshall. Lieutenant Colonel James Keith, acquitted of murder charges three decades earlier, secretly meets Patsy Shelton, widow of Jim Shelton, and mother of two other victims, fifteen-year-old Jim Jr. and thirteen-year-old David.

Keith seeks to ease his soul. He is haunted by ghosts, who appear as characters onstage, and interrupted by his former superior, Colonel Lawrence Allen, sent by

Keith's wife to retrieve him. Keith and Lawrence suspect that Patsy has alerted others about Keith's presence and believe a crowd awaits their departure from the church.

Script changes were made up to the last minute, Austin noted. O'Leary and director Bill Gregg added a ghost—that of Captain Nelson—to include a Confederate among the spirits. The ending was something that involved much agonizing, for descendants of all parties would be in the audience. Even use of the word "massacre" had to be questioned.

History by consensus—it may give many ease. Sometimes it makes the dead turn in their graves.

A Woman's Anguish, an Aristocrat's Fate

A couple of months after General Robert E. Lee's surrender to General Grant at Appomattox, paroled Confederate prisoners made their way back to Asheville, walking from the train in Morganton. Ellen Elizabeth Sawyer, a young woman living on North Main Street in Asheville, came to abandon her buoyant hopefulness and admit, "The overpowering of our confederacy has almost crushed me."

Sawyer—and Asheville women in general—come to life in a letter that she wrote to a New York cousin, Susan Edney, daughter of the man who had owned Asheville's first newspaper, the *Highland Messenger*. The letter, dated June 29, 1865, is in the possession of Frank Roberson, great-great-grandson of Sawyer's uncle, C.W.L. Edney.

"I see from the papers," Sawyer wrote, "that Gov' Swain [North Carolina Governor David Swain, a politician who maintained diplomatic relationships with Northern and Southern leaders] has been appointed one of the visitors to West Point…Mr. Woodfin [lawyer and farmer Nicholas Woodfin, one of Asheville's largest slave owners] has not come home yet. He has been refugeeing ever since the capture of our village which was [on] the 26th of April."

Woodfin once owned the property on which Roberson's home now stands. Roberson figures that Woodfin was hiding out there at Elk Mountain Farm, skirting into the woods on roads his slaves had built.

In Asheville, Miss Sawyer was escorting Yankee guards through her sick mother's house as they searched for hidden Rebels and valuables. The Eleventh Kentucky

treated the Sawyers well, Ellen wrote, "but fathers take care for the 11th and 10th Michigan regiments," who looted their place.

"Gen. Wilson and Col. Hawley from Ohio," Sawyer noted, "said that the Asheville ladies were the bitterest rebels [and] the most independent ladies they had seen in the south." Her womanly grief poured out the most over the murder of her uncle, Balous Edney, retired captain of Company A of the Twenty-fifth North Carolina regiment. His own cousin had led the charge to shoot him down as he'd fled his house in Edneyville—for, Roberson conjectures, many of the killer's siblings had died fighting a four-year war after having been promised only six months of service.

The Twenty-fifth Regiment had lost 95 percent of its troops at several battles—including the Battle of Malvern Hill and the Battle of Antietam—to shellfire as well as to privation and disease. Most of the Twenty-fifth were farmers, whereas Balous was something of an aristocrat, having served as an American ambassador in Salerno and Honduras. The War Between the States was a complex affair, especially in North Carolina, in which gentleman farmers had simple agrarian dreams and hill folk felt the sting of class differences.

"How sad to think," Sawyer wrote of her uncle's fate, "after visiting Rome and roaming over the vine clad hills of the far famed Italy...to meet death in such a horrible manner."

Voices from Graves

The Civil War in Western North Carolina and East Tennessee, called "the rebellion within the rebellion...has never yet come to an end," Wilma Dykeman wrote in her chronicle of the region, *The French Broad*. Rather, the hurt lives on in memories triggered by the sight of landmarks and gravestones.

A simple word on a grave marker can contain an explosive story. "Captain Balous M. Edney," reads the gravestone of the Civil War veteran in the Coston cemetery off Mills Gap Road. The word "Captain" is loaded.

Edney, murdered by his own men on his estate at the end of the war, was also one of the late casualties of a conflict that decimated the mountain South and broke men's spirits. Marshall Styles, author of *My North Carolina Heritage: Descendants of Robert Edney and Anna Wrensher*, has called forth an even more complex picture of Edney's representative agony.

Styles writes that Edney did raise Company A of Twenty-fifth North Carolina Regiment and did "place himself as the General or Colonel, but was moved down in the ranks to Captain, got his pride hurt and resigned his commission. He then set out to be the self-appointed man to track down and execute Confederate deserters without benefit of trial. In the end, he, too, was tracked down and executed without benefit of trial."

Part III: The Civil War

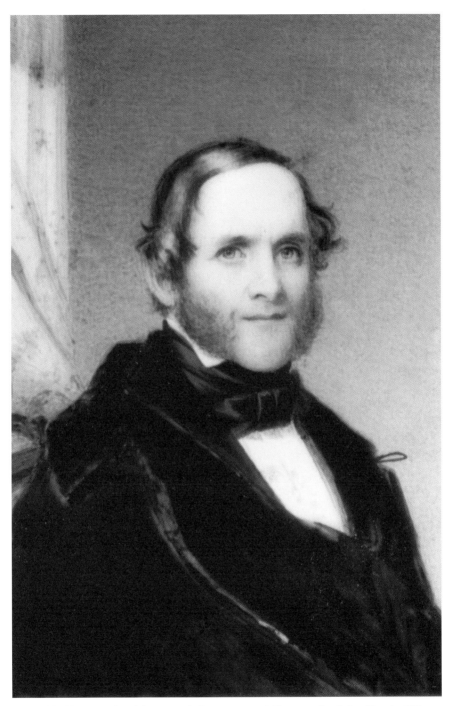

Balous M. Edney, pictured here in a tintype, organized Company A of the Twenty-fifth North Carolina regiment during the Civil War and was subsequently elected captain by his men. *Photo courtesy of Frank Roberson.*

On July 15, 1863, Edney wrote North Carolina Governor Zebulon Vance to express his dismay over the increasing number of desertions from mountain regiments. "There lives no man who is more ardently attached to the war cause than myself," Styles's transcription of Edney's letter reads, "& none more desirous of having every soldier liable to duty to be at his post & that the most rigid execution of military law should be enforced & every deserter & skulker from legitimate duty should be hunted down & punished."

The problem for mountain soldiers was that their homes were left unguarded while the number of depredations by bushwhackers and raiders was increasing dramatically. In a war for states' rights, the independent mountaineers began to resent Confederate authority; and even Governor Vance ardently supported North Carolina's right to judge its own home-returning and fight-resisting troops.

Many deserters went west instead of home—which leads us to the grave of Henry Allen Coggins in the Berea Baptist Church cemetery on Riceville Road. Coggins, a soldier in Company C of the Twenty-ninth North Carolina Regiment, had escaped from Fort Gaines prison in Chicago and fled into Indian country, where he spent most of his long life. At age ninety, he surprised his surviving family and neighbors by showing up at Sunday church service in 1929.

George Coggins, builder of Westgate Mall, was one of the spellbound listeners to Uncle Allen, who proclaimed, "I have never taken the oath of amnesty, never will, and I am still an unwhipped Rebel."

The War of Southern Independence Broke and Released Men's Spirits

The mystery of Captain Balous Edney's murder by his own men at the end of the Civil War is explained only by a little-told aspect of the war. Although the fierce determination of the women who fought for survival at home has received much attention in recent histories, the breaking down of the Confederate soldiers' spirits cries for publication.

There's no doubting the horror of Edney's death. In her letter to her cousin in New York, Ellen Sawyer details the murder scene.

Edney was at home in Edneyville, to which he had retired for a simple life, when he awakened to the sound of a crowd demanding entrance at his door. "Uncle...arose and run down stairs," Sawyer wrote,

> [and] *did not take time to put on any of his clothes except his pants and hat. He ran out the back door. They commenced firing at him through the entry.*

Part III: The Civil War

He started in the direction of the old family burial ground but a guard was there to intercept him. He then started in the direction of the store when he was again surprised by the incarnate fiends, who were thirsting for his life's blood. He again started up thro the old field above his store about ½ mile when he fell pierced by 7 balls in the old field where oft he had roamed in childhood—gay and happy hours—little dreaming that when middle age had stamped his noble brow...he would meet death in such a horrible manner.

Edney, who had organized Company A of the Twenty-fifth North Carolina Regiment, had seen plenty of horrible deaths among his men. The few who'd survived had lost friends and family in an effort that had gone far beyond their enlistment agreements.

Other documents—including 218 letters between soldier James Henderson of Pigeon River and his wife, Maria Henderson—show how eagerness had turned into dread, confusion and religious passion.

By July 10, 1862, Henderson of Company F of the Twenty-fifth Regiment, had already been in a couple of bloody fights in swampland near Richmond, Virginia. He wrote his wife: "I can make out if I don't git in another fight, which I don't want to for I don't fancy the balls and bomb-shells a-flying as thick as hale around my head." He goes on, "I think I could tell you something to see men lying all around me and some hollering that I am killed and some a-crying I am a-wounded. I saw 40 dead men in 4 row square and a grave."

Ten months earlier, writing from camp, Henderson had suffered mostly from loneliness, yet his spirits were high enough to inspire him to write a ballad:

And since we parted long ago
My life has bin a scene of woe
But now the joyful hour has come
And now I have good news from home.

By January 1863, soldiers were deserting in numbers and, if caught, were executed before the troops. On August 23, Henderson started resorting earnestly to prayer to bring God's blessing to the righteous. In September, he reported to his wife many conversions and exclaimed, "I trust to Elijah's god that religion may spred over our land and nation and that prayers may be constantly ascending to god for the Southern states."

Last Confederate Victory— in Swannanoa Gap

April 20 marks the anniversary of the last Confederate victory of the Civil War, it may be argued. It took place at Swannanoa Gap, about where the interstate highway sign in Ridgecrest reads, "Welcome to Buncombe County."

In mid-April 1865, nearly three thousand of General George Stoneman's light cavalrymen proceeded from Morganton to Asheville, led by the punishing and plundering General Alvan C. Gillem, who had taken command of the Union regiments after Stoneman had leveled Salisbury's prison and headed home to Tennessee. The news of Gillem's approach reached Asheville ears before the news of an event eleven days older, General Robert E. Lee's surrender at Appomattox.

In Wild West movie fashion, Confederate General James G. Martin rallied about six hundred Asheville troops and hied to Swannanoa Gap, where the men, armed with muskets, positioned themselves in a deadly U on ridges above the terminating valley. "Stonemen's men could not reach the gap because their route had been barricaded by felled trees in the mountain gorge," Confederate veteran George Fortune of Black Mountain recalled in 1928.

Gillem's scouts, hindered by timber and endangered by musket balls, instigated the retreat of two regiments. It was a severe and bitter embarrassment to the Federals, who had been outfitted with the latest military technology, Spencer carbines—seven-shot repeating rifles. In need of vindication and further enraged by news of President Lincoln's assassination, Stoneman's raiders made their way to Asheville via Howard Gap on April 23, traumatizing with lasting effect the residents of Henderson County.

Terrell Garren, historian, says that his novel about the Civil War in the South, *The Secret of War*, "would never have been written if the Confederates had not won the battle at Swannanoa Gap." The raiders' detour "had put them in direct contact with my ancestors," he reveals, "and inspired years of research on my part."

Garren can point out the place where Martin had granted Gillem safe passage through Asheville over three days. That local armistice had been enacted on land now occupied by the Budweiser beer plant in Skyland. Interested in personalities,

Part III: The Civil War

Garren dramatizes Gillem's treachery—his sack of Asheville and imprisonment of its citizens in transport cages—as well as Gillem's supervisors' consternation over his actions. And Garren can show you his analysis of a recently compiled list of Union soldiers in Henderson County; it had been filled out with Tennessee carpetbaggers who never showed up on local censuses from previous decades.

The Claim Debated

Astute readers have noted that historians consider the Battle at Palmito Ranch, Texas, May 12–13, 1865, the last Confederate victory of the Civil War, contradicting the claim that the Battle at Swannanoa Gap on April 20, 1865, deserves that distinction.

The key point is that the war had ended not at Appomattox, but in a series of surrenders, with General Robert E. Lee's surrender of the Army of Northern Virginia being just one. The Trans-Mississippi Army had taken longer to yield and had been ready to harbor the fleeing President of the Confederacy Jefferson Davis and possibly join forces with Mexico.

The safe course to take regarding local history is to revise the claim regarding the Swannanoa Gap battle and call it the last Confederate Civil War victory in the east; or, the last before news of Lee's surrender. We know that General Edmund Kirby Smith, commander of Confederate forces west of the Mississippi, had known of Lee's surrender before May 12; and we know that General James G. Martin, in Asheville, had not known by April 20.

The Asheville area had first learned about Appomattox when paroled soldier Perry Gaston had arrived home in Hominy Creek three weeks after Lee's surrender on April 9. He'd walked from Virginia.

The Palmito Ranch event not only followed Lee's surrender, but also—by two days—the Federal capture of Jefferson Davis, and thus the end of the Confederate government. How should we determine when (and some say, if) the Civil War and the Confederacy ended? Skirmishes between opposing soldiers continued after May 12, and even after the May 26 Trans-Mississippi surrender. Yet, as historians point out, none were fights between "sizable bodies of men."

There are other wrinkles to this story. The office of the quartermaster of the Thirty-fourth Indiana Regiment (Union) reported on May 17 that the commander of the Texas post, Colonel Theodore H. Barrett of the Sixty-second U.S. Colored Troops, "started a colored regiment to Brownsville, on the Rio Grande, in direct violation of orders from headquarters." The Federal report, published in the *New York Times*, June 18, 1865, went on to state that "the rebel General told one of our captains that if the white regiment had come up alone they [the Confederates] would have surrendered to us…they believed the war was played out, but thought this was a good opportunity to give us a whipping."

In other words, it might be argued, Palmito Ranch was not a Civil War battle, but a skirmish, made distinctive by its size. It was characterized by the kind of enmity that had fueled Union General Alvan Gillem's men when they had taken Asheville Confederates prisoner on April 26—after knowledge of Lee's surrender and after a local armistice, in violation of Gillem's commanders' codes of conduct.

PART IV
LEGENDARY WOMEN

Lillian Exum Clement
First Female Legislator

T here's Ex," Nancy Stafford Anders says to herself, acknowledging the presence
of her mother, Lillian Exum Clement, in a 1999 ceremony commemorating
Clement's trailblazing achievements. In the Buncombe County courthouse, several
prominent women noted their indebtedness to Clement for reasons summarized by
a newly dedicated North Carolina Highway Historical Marker.

"Lillian Exum Clement Stafford, 1894–1925," the sign reads. "First female
legislator in the south."

In 1920 an all-male Buncombe County electorate ushered Clement into the
North Carolina General Assembly by a vote of 10,368 to 41. During her term of
office, she managed to get sixteen of her seventeen bills passed and then chose to
return home to her husband, E.E. Stafford, to have a baby. Two years later, Exum
Clement died of pneumonia. Her devotion to her daughter survives in diary entries
addressed directly to her child, Nancy.

"Last night you slept with some one besides Daddy and Mother for the first
time," Clement wrote on February 10, 1925, eleven days before her death. "Daddy
was sick and Mother was sick and Aunt Nancy came in and spent the night with
you…You say 'God' 'God' 'God' (meaning God would make you well), and he
surely will."

Nancy recovered, but her longing for her mother made people cry over her. Two
years old, she greeted the frequent guests at her family's home with the plaintive
question, "Where's Ex?" Once, out in the yard, she thought she had spotted her.

"We had a beautiful lawn with a high hedge around it," Nancy Stafford Anders,
now called Stafford, recalls. "I was playing out on the lawn. I saw a little red and
white checked dress, and not a very tall woman in it who was walking on the
sidewalk [on College Street]. I remember the joy. I have never felt this emotion
this strong again. I ran to the end of the hedge—there was a place where I could
get through. I was so disappointed when I saw just some woman walking down the
street. I thought maybe my mother was coming back."

"Where's Ex?"

"There's Ex," Anders realized years later, referring to her mother's enduring legacy.

Exum, as she was called, was the sixth of seven high-achieving children of
George Washington Clement and Sara Elizabeth Burnett, both of whom had

Part IV: Legendary Women

Lillian Exum Clement had to hide her attractiveness in order to avoid distractions in the North Carolina Legislature. *Photo courtesy North Carolina Collection, Pack Memorial Library.*

brought to their home on the North Fork of the Swannanoa River culture-rich family traditions. George's family had been Hillsborough planters. When Federal troops swept through in the Civil War, thirteen-year-old George enlisted to fight them, but he could neither prevent the death of his mother nor the destruction of the family estate.

Undefeatable, George had gone to work, supervising railroad crews and working his way from a coastal town named Exum to Black Mountain. There,

he met and married Sara Burnett, whose family had been in the area for decades and whose ancestors had fought at King's Mountain. Stories of Clement family life were passed on to Anders by her Aunt Nancy, who raised her after her mother's death.

"There were no libraries in those days, and especially in Black Mountain, which was a wide place in the road," Anders relates. "But somebody came through selling books. One of the books was an encyclopedia…Grandfather bought the children one. In there was *The Merchant of Venice*. Mother [Exum] was so impressed with Portia. They said when she was just very small, she was going around saying, 'The quality of mercy is not strained. It falleth like the dew from heaven. It is twice blessed for them that receive and them that give.'"

The story about Florence Nightingale influenced Aunt Nancy, who later worked as a nurse in Oteen. "Nightingale got women who were camp followers into being nurses," Anders reflects, "and it wasn't quite decent. I mean, a woman would be married fifty years, and never see her husband without his nightshirt—and she was supposed to nurse wounded men?"

Women's Lives at the Turn of the Century

When Exum and Nancy were growing up, society did not provide women opportunities for self-expression. Wine of Cardui advertised its alcoholic medicine as a help to women who "prefer to suffer untold miseries rather than confide her troubles to a physician."

A popular poem of the day brayed, "O, she's nothing but a woman, fit for heaven, unfit / For a seat where pious bishops and where righteous laymen sit." And a judge lecturing at the Swannanoa Country Club stated, "Women should not be classed as idiots or lunatics," but the consent of their husbands should be required in conveyance of property.

Yet the Clement girls, after their father went to work as a foreman for George Vanderbilt, benefited from the support of one of the leading women of that era, Edith Vanderbilt. Encouraged by her, Exum enrolled in the newly established Asheville Business School. She learned typing skills there and also came to realize in her dealings with the men that she could compete with them intellectually. At age fourteen, she went to work in the sheriff's office, and over the next eight years, followed up her day job with night classes in the study of law.

In February 1916, Clement passed the bar exam with top grades and was officially welcomed into the Asheville legal profession as "Brother Exum." Historians credit her as being the first female lawyer in North Carolina to practice without male partners.

Anders notes that her mother "would not take the case of a man who was guilty. She wasn't a goody two-shoes, but she said that she couldn't be convincing."

Integrity was part of her style, as was a quiet modesty that attracted men. While she was a lawyer, two men had fought a duel over her and fired shots.

"It's said the last duel fought in Asheville was fought down in what is now Montford Park between well-known gentlemen of the time over mother," Anders recounted. "Everybody thought this was exciting and titillating, but she was humiliated. She said, 'Am I supposed to go off with the winner like a lady rhino?'…Aunt Nancy said all the other women thought it was so romantic."

By 1920, the women's suffrage movement had gained great momentum, and Buncombe County Democrats nominated Exum Clement as their candidate for the Assembly. Her landslide victory speaks to her ability to ease men's fears about women. The *Raleigh News & Observer*, reporting on her first day in the House, quoted Clement as saying: "I was afraid at first that the men would oppose me because I am a woman, but I don't feel that way now. I have always worked with men, and I know them as they are. I have no false illusions or fears of them. You may quote me as saying, 'I am definitely for them.'"

Photos of Clement as a legislator show that she altered her appearance to avoid the pitfalls of her natural beauty. Heavy glasses and a pulled-down hat were part of her get-up. Still, some of her male colleagues expressed romantic intentions.

In a letter to Eller Stafford two months before they married, Exum wrote: "Several of the men have invited me to go home with them for week ends." Another legislator tried to act as matchmaker, recommending her to a bachelor in the Senate, who was also "high-brow." And then there was Baxter Durham, "the only man I have met that doesn't speak to me. But he doesn't stand very high here."

Mother Love and Legislation

With her timid but firm and conservative manner, Exum Clement enacted landmark legislation, including bills that required privacy in voting and inoculation of cows against tuberculosis. Her most controversial measure was solicitation of state funds for the support of the Lindley Home for Unwed Mothers. At a speech in Biltmore, protestors pelted her with fruit, provoking her to quote the Bible.

Clement's interest in the Lindley Home related to an experience that hit close to home. Out of a window of her office on Pack Square, Stafford Anders relates, she once "saw a young girl sitting on a bench, and it suddenly dawned on Mama that she'd been sitting there a couple of days. So she went down and talked to her and found out that she'd come out of the mountains…and went to work for a wealthy family here in town. The son of the family seduced her, and when she became pregnant, the family kicked her out…She was about sixteen. She had no place to go…Mother brought her home."

A few months after the girl gave birth, Exum gave birth prematurely to her daughter, Nancy. Exum was sick, and turned to the unwed mother she'd aided for

a wet nurse for her child. "Mother has been so ill that all Nancy girl's dinner dried up," Clement wrote in her diary on June 13, 1923. "Mother wants her darling to stay with her, but what is good for baby is good for mother."

Lillian Exum Clement was a woman of many desires and skills, and she was aware of her own physical limits. In a letter to Eller Stafford from the State House, she'd written: "Now Eller dear, please don't ever mention Congress to me...I am going to do something that will build up my nervous system and not tear it down. I wish you would not encourage Papa, but please help me to get any such idea out of his head."

It was her health that brought Clement down. Her grandfather, who idolized her, died with her name on his lips. A cousin, visiting Anders many years later, saw a vision of Exum on the stairway. People couldn't forget her.

In 1998, a group called "Lillian's List" was formed to support pro-choice, Democratic women for North Carolina office and to provide scholarships to women attending law school. The Women's Club of Raleigh has successfully spearheaded a movement to have a historical marker erected for Clement. More and more, people are saying, "There's Ex."

The Girls of Candler

In Candler before and after World War I, farmers worked hard to have their daughters as well as sons leave the farm. James Thaddeus Cathey and his wife, Ida Lou Eva Wright, left their productive acreage along Pole Creek to rent land from Eva's brother, Zeb, on Justice Ridge Road in 1923—just so their children could walk to Candler Academy, an early school.

Eva Cathey was fifty years old at the time of the move. She had eleven children—the youngest, age ten. Her oldest three children had left home years before; and her fourth, Mary Lee, a dainty girl, had assumed the role of assistant homemaker because of her lameness, brought on by osteomyelitis.

Cathey, daughter of Marion Wright, biggest landowner in Pole Creek after the Civil War, had had a tantalizing taste of education herself when she'd been a girl. She had accompanied two brothers to Weaver College (forerunner of UNCA) in Weaverville to serve as their housekeeper as they studied.

"Mama read a lot and was interested in languages," says her ninth child, Florence Cathey. Florence recalls hearing her mother say to her father on numerous occasions, "We have to do better for these children."

Part IV: Legendary Women

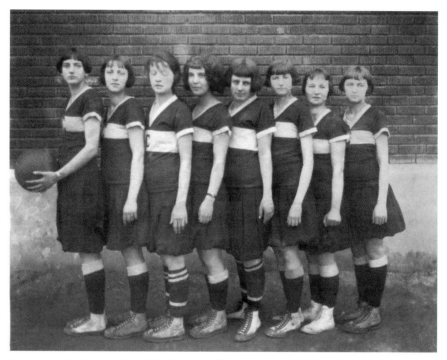

Pictured is the Candler High School championship girls' basketball team of 1925. *Left to right*: Florence Cathey, Margaret Whiteside, Charity Williams, Betty Osborne, Nora Belle Reese, Charlotte Cathey (Florence's sister), Hattie Williams (Charity's sister) and Jennie Cathey (Florence's cousin). *Photo courtesy of Florence Cathey.*

It was at Candler Academy and then at the newly built Candler High School that Florence had become a basketball star. Basketball was new for girls and was another symbol of changing expectations for women. Florence recalls that the pioneering coach, Ed Warrick, had looked at her long legs and big hands, had run her around the academy grounds a few times and had said, "You're in."

The girls were so motivated, they bought their own uniforms, which included pleated bloomers. At Candler High School, where the girls' team won three championships, Florence at center was the Michael Jordan-like leader. "I shouted the whole time," Cathey says. "I wanted to win every game." Later on, Beacon Mills picked her up for the Industrial League, where she played on a team that introduced short pants and tops with no sleeves.

One of the high school team's guards, Hattie Williams, was glad to be playing basketball after having had to take two years off from school, once after her mother's death from typhoid fever in 1914 and once during the 1920–21 flu epidemic. Debbie Williams Hall, the oldest of seven children in that family, says that her father had left his farm in 1920 to move closer to the Candler Academy, just as the Catheys had done.

Debbie Williams had made sure that she and her siblings got to school every morning after a breakfast of cornbread and pumpkin butter. One time, when she had had laryngitis, Williams says, "I woke up and fixed breakfast and didn't say anything because I didn't want Dad to find out."

The teacher seated her next to the stove for her health, but didn't send her home. Candler family trunks are filled with the perfect attendance certificates of early students.

They Loved to Play

When Jennie Cathey Robinson, a Candler farm girl in 1920, completed her daily school and farm work, she played. She played not only Ant'ny Over (involving teams throwing a ball over a roof), but also basketball, a new sensation. "We played 'til dark, washed our feet, and went to bed," Robinson says with a laugh.

Florence Cathey, Robinson's cousin, often engaged in one-on-one basketball with the same fellow with whom she went to dances—Coke Candler, a future basketball coach and county commissioner. Cathey's home is on a road, which, according to local lore, was once named "Girlfriend Road," apparently by Coke Candler in honor of Cathey.

The Cathey cousins both became members of the Candler High School championship girls' basketball teams in 1923–26 and representatives of a class of women encouraged to excel in school, sports and the working world. These young women were benefited by parents whose education and relative prosperity led them to lift their children beyond the hardships of subsistence.

Robinson's father, Robert Lee Cathey, carted produce, dairy products and eggs to market twice a week. He also ground sugar cane for molasses and manufactured tool handles. Jennie's job was churning butter. "I tried to knock the bottom out of that churn because I hated that job," she recalls.

Robinson notes that both her parents were well read. "There wasn't a word in the vocabulary they didn't know," she says. Maynard Fletcher, a neighbor, used to come by regularly to hear her father read the *Asheville Citizen* aloud.

Debbie Williams Hall, whose sisters Hattie and Charity were both on the Candler basketball team, did not have all of Robinson's advantages. She was nine when her mother died of typhoid fever. Debbie Hall, the oldest child, remembers caring for her tiny baby sister, Thelma, nicknamed "Cricket." "I gave her a bath and took care of her," Hall says. "I cut her hair 'til she was in high school." In the meantime, Charity took up the responsibility of chasing down chickens for dinner.

Despite the Williamses' loss, the girls completed high school. Their graduating classes contained six times as many girls as boys, who often went to work as soon as they were able, sometimes traveling to the Far West. Debbie

proceeded to Teacher's College in Cullowhee, got her teaching certificate and taught one year. Then in 1929, Enka, the Dutch rayon manufacturer, opened a plant nearby, and Debbie—like many women taking advantage of the plant's practice of hiring female employees—got a job in the reeling department.

"The day I applied," Hall recollects, "the office was full, but only two of us were hired…A man interviewed me for about thirty minutes. He asked about my education. I think he had all the names of my family."

Jennie Robinson's employer at Enka in 1929 also knew about her. He seemed to have the heads-up on her hoop-shooting prowess for he soon placed her on the factory's fledgling Industrial League team, the Rayonettes.

Getting through the Depression

In 1937 the Enka factory's women's basketball team, the Rayonettes, came within one point of winning the national Industrial League championship. The team's supremacy symbolized a remarkable surge of willpower among Candler area girls in the 1920s and '30s.

Basketball had just become popular for girls. Textile mills, in their efforts to create team spirit among their thousands of female workers, had established a women's division of the Southern Textile Athletic Association in 1920. Suddenly, girls such as Jennie Cathey, a Candler High School forward, were erecting makeshift hoops in backyards and barnyards and learning to jostle for good shots.

Candler High School, established in 1923, had found ready competitors at Sand Hill, Asheville, Canton and other schools for its girls' team, and dominated them over the next fifteen years, winning many championships. "I wasn't such a fine player, but I was aggressive," says Judith Saunders Herren, a forward on the 1932 to 1935 teams. In one game, Herren had scored thirty-five points, a record. At the time, thirty points was high for a team.

The fierce competitiveness sometimes carried beyond the court and, Herren recalls, the Candler girls once found themselves being stoned as they headed toward their bus after a meet. Ed Warrick, Candler's principal, counseled maintaining sportsmanlike conduct in face of the attack. The coach, however, had disliked not taking a stand.

Community members attended Candler games even if they didn't have relatives playing in them. Herren's future husband, Jack, had been in the stands when he'd noticed Judith's basketball playing sister, Azile, and thus formed an attachment to the Saunders family.

Jennie Cathey's parents, attending to their farm and home five miles from the school, were not able to see their daughter play, but they encouraged her. Cathey's consequent independence and drive led her to leave high school before graduating and grab a precious job in the sorting department of the

newly opened Enka plant. In the sorting room, four rows of women spent all day running their hands through skeins of rayon silk, rejecting those skeins in which they found flaws.

"You had to work hard to make the quota," Cathey says. "You had to have your eyes constantly on this bright light."

It was the Depression. Jennie Cathey and her husband, C. Floyd Robinson, were paying off the house his father had built. Debbie Williams Hall, two of whose sisters played basketball, cut short a teaching career to work at Enka. Florence Cathey, Jennie's cousin and a Candler High center, stopped playing basketball and studied at Cecils Business College.

Not all girls sought jobs. "I didn't want to go to business school," Herren, now a great-grandmother says, looking back on a maternal career that included taking children not her own into her home. "I stayed with my mother, who was a seamstress, and then I got married. I wanted to have a family."

Leaving the Farm

Farms in Candler provided a rich life to their residents even through the Depression, yet when other opportunities opened up to young people, the farmers did all they could to help their children leave the farm. The daughters blossomed, filling the graduating classes at Candler High School and, nourished by farm food, forming a basketball team that dominated the region.

"The land in Candler was better than elsewhere," Doris Lance Plemmons, a 1934 Candler graduate, surmised. "Erskine's [her husband's] family lived in Turkey Creek. I couldn't believe all the red clay they had. Their tomatoes would be sour, ours sweet. We had some good bottom land."

A typical midday meal at the Lance house in the 1930s was dried beans, Irish potatoes, cabbage, turnips, pickles, kraut and, Plemmons says, "always apple sauce, which we called 'fruit.'" Blackberry pie was an everyday dessert, and there also was often wild meat.

Doris Lance and her three sisters shot up like sprouts. They did not play basketball, but they all went on to salaried careers, including Doris's role as preacher's wife and church secretary. Doris was Emma Robinson Lance's third daughter in as many years and was puny at birth. She fell prey to sickness throughout her childhood, which may have stemmed from her zeal as a student.

"In high school," recalls Plemmons in a seventy-eight-page memoir, "we walked a mile to meet the unheated bus…in bad weather it was usually late…[and we'd] arrive at school late—no time to hover over the radiator, and all the seats close to the radiator taken."

Going home, Plemmons waited for a bus that had to make three runs. She and her friends took advantage of the time to watch the girls' basketball practices. Even

for the non-basketball playing Candler girls, the sight of those determined female athletes was an inspiring image.

Madeline Peeler, a classmate of Plemmons, got to know her future husband, Eugene Debs Gudger, at basketball games. She lived in Candlertown, near the depot; he in Luther. School brought them together. After graduation, they got jobs and married.

A.C. Reynolds, County Superintendent of Schools, had urged Peeler to attend junior college, but her family couldn't afford it. Instead, she and four girlfriends took a day off to apply for jobs at the Enka plant and at stores in Asheville. All five got jobs at Enka.

Enka was the safety net for high school graduates. Doris Plemmons's sister, Ruth, married Roscoe Jackson, the oldest of eight orphaned children, knowing that she would share her husband's responsibility for them. She took a job at the rayon plant to help out. Later on, she became an interior designer with Brookshire Interiors.

Plemmons never worked for Enka. The close, nurturing and religious life she'd experienced on the family farm pointed another way. When Erskine Plemmons showed up at Liberty Baptist Church one winter as the new pastor, Doris, seventeen years old and a church program coordinator, threw a snowball at him.

Girl of the Lumber Camps

Riding with her daughter, Janis Allen, to Janis's new home in Brevard in 1999, eighty-six-year-old Pauline Ruff Allen noticed a sign on the interstate that read: "You are entering Transylvania County."

"I used to live there," said Pauline.

"You did? When?" asked Janis.

Pauline then visited a long-forgotten year of her life. She'd been four and her father had worked in a lumber camp in the Pink Beds. To further elicit the tale, Janis escorted her mother to the old site.

The two found no sign of the lean-to that the Ruffs had called home during the summers of 1917 and 1918. After all, it had been a provisional structure. Lumber companies, which had been harvesting the region's hardwoods since the 1880s, overcame their biggest problem—poor access to the timber—by setting up temporary camps for workers in dragging distance of racing rivers.

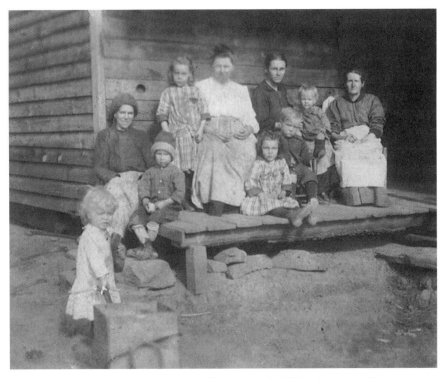

The Ruff family left the lumber camp in the winter of 1917 and went to Cane Creek in Polk County, where they celebrated Christmas at their Aunt Parlee's porch. *Photo courtesy of Janis Allen.*

The period's biggest industry had been a gypsy affair, practiced in parts that were remote by design. That's where the virgin trees flourished.

Pauline's childhood residence, constructed by her father, Hampton Ruff, had stood so far from any road that the family had had to depend solely on the company train for contact with civilization. Once a week, Pauline's mother, Maude Ruff, ordered groceries.

The children especially remembered the receipt of brown sugar. "If us kids got ahold of it when Mama was outside," Pauline recalled, "we'd eat the whole week's supply in the first two days.

"Mama soon outsmarted us. She tied the brown sugar inside a cloth bag and hung it up on a nail from a rafter so we couldn't reach it. I remember my brothers lying down on the floor under that bag, begging and crying for Mama to get it down and let them eat some brown sugar."

Other memories were of pioneer parents who seemed legendary. In the evening, the Ruff children went down to the river to see their father and other loggers returning home atop the day's last logs. They gleefully checked to see if anyone's pants were wet from having fallen into the stream.

Pauline's mother shot and dressed squirrels, made dolls out of flour sacks and kept track of young children in an environment not unfrequented by bears and panthers. One time, going out to hunt, she placed a bed leg on her little son Pete's dress-tail so he wouldn't wander.

Tired of seasonal work, Hampton Ruff took his family to Caroleen, South Carolina, where he got a job in the Burlington cotton mill. Pauline met her husband there and took pride in making shirts for World War II sailors. Shortly before she died in 2003, she began to write furiously, keenly aware that her life had touched upon many key episodes in regional history.

"Lots of Love from BB" The Wartime Letters of an Asheville Nanny

Several dozen letters from Bee Frazier to Helen Maynard—whose son, Jordan, Bee took care of from birth to age seventeen—come down to us from the 1940s and reveal a black woman's life in wartime Asheville. When Helen and her husband, Robert Maynard, Asheville city engineer from 1930 to 1939, moved to Atlanta in 1942, they asked Bee to come along, but she declined. Instead, she wrote letters every week, often closing with the phrase "lots of love from BB."

The letters repeatedly express Frazier's devotion to Mrs. Maynard and her unconditional love for Jordan. A triangle had been formed in which attention was given in all directions. "I had a letter from Jordan last week," Frazier wrote Mrs. Maynard in 1946, while their boy was still in the service. "He said he hant had a letter from you all in two or three days. I try to write him every week. I get a letter from him prackley every week."

Jordan Maynard has many memories of his days and years with Bee. He recalls she'd take him to Claxton School to play on the swing sets. The boy's grandfather, former police chief Frank Jordan, would sometimes stop by on his walk home from work. "Every time I'd see him," Maynard said, "he'd give me a dime. I thought that was great. Bee would go home and tell my mother." His mother put a stop to that practice.

Another time, two neighborhood boys robbed Maynard as he made his way home from the YMCA. Frazier organized a search party, called the police, jumped

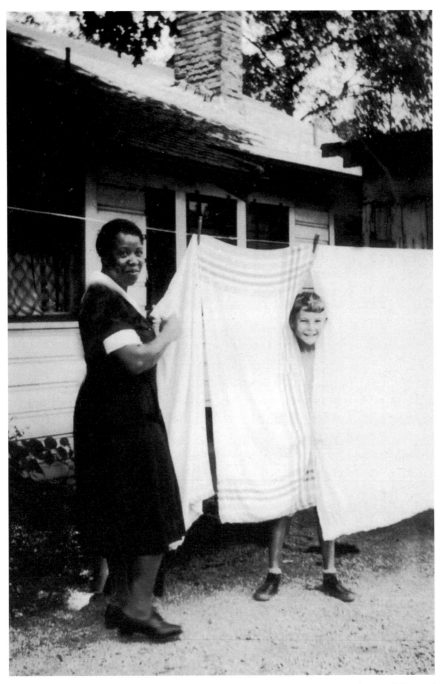

Bee Frazier looked after her charge, Jordan Maynard. *Photo courtesy of Jordan Maynard.*

Part IV: Legendary Women

in a car and questioned kids until the two perpetrators were found. Maynard recollected, "She was so mortified that anybody would bother me. She couldn't understand why anybody would bother her boy."

Those were Frazier's glory days. She lived at 37 Magnolia Street among familiar neighbors, and the Maynards were nearby—for some years at 80 West Chestnut Street and then at 48 Woodward Avenue.

The 1940s, however, brought separation, privation and failing health to Bee Frazier. Mornings before going to work, when her energy was high, she opted to write letters. By the time she got back home, she was ready to collapse. "I be so tired I don't know if I am going or coming," she wrote. "Some days I don't get to sit down from the time I leave home in the morning until I get back that night."

Frazier felt old; she "was going through the change," her doctor said, and she was losing her vision. "I have got so I just hate to write," she confessed to Mrs. Maynard. "I can't see so good when I look on white paper so long."

The Maynards sent Frazier money and gifts to help her maintain her health and morale, and Frazier thanked Mrs. Maynard "a million & a million times," but she also sent many gifts herself. Knowing that food shortages were in some cases worse in Atlanta than in Asheville during the war, Frazier would hunt for such items as butter, sugar, canned goods and nucoa to send to her former employer. Once she sent Mrs. Maynard stockings.

The lack of sugar became apparent as early as 1942, making it hard for Frazier to can peaches. She depended on the produce that she herself grew and canned to get through the winter. Gasoline shortages meant that more people were riding buses or walking. Lack of coal led people to cut their trees down.

Shortages of flour caused one neighbor, a baker, to take a job in the Jax Pax meat department at Chestnut and Broadway, but then there was a meat shortage. Frazier wrote Mrs. Maynard that the poor baker "was only working three days a week now, he can't get any meat to sell. I guess the peoples going to hafter drink water & suck their thumb. Meat is just out the question in Asheville."

The war years tested character. Frazier sometimes engaged in social observations about people who fell short. After all, she was accustomed to the Maynards' high standards (the story is that Robert Maynard left Asheville because he refused to play the payola game in politics), and she maintained high standards herself. Nonetheless, we can read into her accounts the compassion that the hard-luck souls were due.

One neighbor, she wrote, "took some money from the company where he worked so they fired him." Interrogated, he went crazy, she said. "They say he would get in his room in the day time and lock the door and stay in there all day and won't let nobody in there and he won't come out. Just as soon as night came, he would come out and walk through the house all night long and his wife was afraid of him so they had to send him off."

Frazier once worked for a couple who expended money on a new car and on supplies of whiskey and beer, evidently burning the candle at both ends. They ate very little (Bee attributed it to stinginess) and didn't pay their debts, but they were so dependent on Frazier for housework and child care, they paid her regularly and surprised her one Christmas with a gift of twenty dollars.

Frazier observed of her sad employers, "I don't know how they have any friends. They don't send any Xmas cards or give a present to anybody. She don't try to make friends with nobody that have little girls. She don't read anything, don't try to sew or go anywhere, just sits & hold her hands."

Perhaps the saddest fracture in Frazier's life at this time was her husband's change of attitude. She'd been married to him twenty-five years when his fortunes rose and hers flagged and he turned ugly. After a break, when she had left town to flee him, they reconciled, but the marriage wasn't the same. He never gave her a penny, and on her birthday, only the Maynards came through with love. "I told John today is my birthday," she confided to Mrs. Maynard. "He didn't open his mouth. It made me feel kinly bad."

Through it all—through the war years documented in her letters—Bee Frazier maintained high spirit and humor. Following her birthday experience, she threw herself her own wedding anniversary party. Regarding her husband's new job (a war-related one), Frazier told Mrs. Maynard that he is "going into chemist work so I am going to put him in a heavy insurance for I know they are going to make something to blow up Asheville ha ha. When he leave home every morning I don't know if he get back all together or not."

She could laugh about her own poverty. In response to one gift she received from the Maynards, she wrote, "Tell Mr. Maynard I am using the drawer he sent me. I have a knife in one side a fork in the other and a spoon in the other. Ha ha."

Frazier worried about and prayed over "her little boy" Jordan's stint in the U.S. Air Force. When Jordan noted in a letter to her that the food in China wasn't much, Frazier offered to send him cans of chicken noodle soup.

She also wanted to share in his triumphs. "Well when you learn to fly an airplane," she wrote him when he got his wings, "you can take me up in one for I will be so old I won't know what I will be riding in any way. John will make something to give me to keep breath in me while I am riding in the plane."

When Frazier was happiest, she expressed it as being "tickley" [tickled] to death. "I am tickley about Jordan," she wrote Mrs. Maynard after she had gotten help from Jordan with her glasses and had received a gift of Florida oranges from him. "I wonder what everybody think about him now. When he was little everybody thought it was awful the way we let him climb all over the furniture & play in the house. I know he will make it anywhere because he is nice & kind to every body."

Frazier was also tickley to death about beautiful things that Mrs. Maynard sent her—yellow drapes that she showed off to the whole neighborhood and dresses that

lifted her out of the doldrums. In one of her last letters, she wrote Mrs. Maynard, "I am at home now. I am not working anywhere. I just feel lost. I work my self to death at home trying to stay busy, so used to doing something all day. Thanks again Mrs. Maynard for the dress."

Trainmen's Wives

Integration and the hiring of African American men on the Southern Railroad gave birth to a powerful force in Asheville's black community: trainmen's wives. The trainmen were husbands who were willing to sacrifice family time, opportunities for sleep, less hazardous work and jobs that did not buck the racial hierarchy in order to be good providers. They sought out and married women who were both morally upstanding and rebellious.

Claudia Tucker, wife of flagman and later conductor Charlie Tucker Jr., recalls as a child being told by her mother never to go to Eagle Street, scene of African American jazzy nightlife. Tucker says, "I would sneak up every chance I got. When you tell me to go east…I'll find time to go east, but then I'll go around to the west."

Pauline Seabrook married Curtis Seabrook Jr., a red cap who became the first African American conductor in Asheville. (She herself became the first black Licensed Practical Nurse at Mission Hospital.) The two met at Rock Hill Baptist Church, where Pauline was attending a Sunday school convention and Curtis, a Methodist, was showing an interest in fine young women. It was the civil rights era and Pauline with her best friend, Julia Anna Mays, occasionally went downtown and took stands in protest of second-class treatment at Woolworth's and Kress's lunch counters.

In the late 1960s, a couple of years after their husbands started as trainmen, Tucker and Seabrook decided, over the phone, to form a society of trainmen's wives—in order to support a railroad wife whose illness prevented her from caring for her children and also to deal with loneliness.

"As my kids grew older," Tucker relates, "they…would always ask, 'Mama, why is Daddy not home?' I had to tell them, 'you wouldn't have all these things if Dad was home all the time.'"

Although "The Society of Railroad Trainmen's Wives" evolved into a major support organization for a wide range of causes in Asheville's African American neighborhoods, the primary focus of the women has been the rearing of happy, virtuous and successful children.

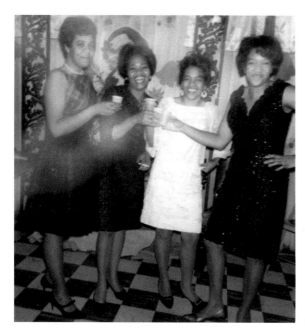

Right to left: Trainmen's wives Pauline Seabrook, Dorothy Kelly, Bobbie Christopher and Seabrook's friend Julia Anna Mays were attending a trainmen's wives party at a posh house in the 1970s. The elegance of their social events led to their being the first black group permitted to rent a ballroom at the Grove Park Inn. *Photo courtesy of Pauline Seabrook.*

Seabrook was an effective practitioner of tough love. "My second son was a pretty one," she recalls. "Girls called him all the time…Once, he came home after the 12 o'clock curfew and I locked the screen door. He banged and knocked. I said, 'Nobody let him in.' He went to a friend's house and slept on the floor. He never missed a curfew again."

The trainmen's wives taught children how to be proud of themselves and not make excuses for their troubles. They stressed the importance of education and made sure that there was a piano in the living room and a list of responsibilities on the refrigerator door. Of the seven children of the sick woman whom the wives had originally helped, five went to college and all seven got professional jobs.

Growing up Black in Black Mountain

The racism that Inez Virginia Daugherty experienced growing up black in Black Mountain in the 1920s was brightened by black and white acts of integrity and heroism. "The children in Cragmont [a black neighborhood] and

Part IV: Legendary Women

High Top Colony, where Daugherty's family lived, walked to school in groups," Daugherty recalls. "White children rode the bus. They sometimes threw things at us and called us ugly names, but my mother told me, 'You know who you are. Those names do not apply.'"

A girl from one of the white High Top families borrowed books for Daugherty from the library, from which African Americans were barred. "If the library people had known about it, they would have banned her," Daugherty notes.

Daugherty's father, Robert Morehead, owned a lot of property in the area. He sold some of it to Roy John for his development of the High Top colony. Morehead, a farmer with two mule teams, hired himself out for hauling, plowing and grading jobs.

"One day," Daugherty relates, "a white man approached papa. 'Bob, would you haul something for me to Madison County?' he asked. My mother was frantic. 'Please don't go,' she said. My father replied, 'His money looks just as good as anyone else's.'"

The next morning, Daugherty and her siblings heard their father's account of the adventure. "I went to Madison County to help a family," he said, "and I have never ever been treated any better by anyone. I ate at their table and slept in their bed, and they invited me back anytime."

It was quite a contrast to the Jim Crow laws that kept the races separate in every sphere of life before the 1960s. "Separate but equal" is what the Supreme Court mandated in 1896 with *Plessy v. Ferguson*. But things were far from equal.

When the Carver School was built for the black community in Black Mountain, it lacked kitchen equipment. Daugherty and her PTA group had to raise the funds. When Stephens-Lee High School was opened to African Americans in Black Mountain, black folks had to raise the money for a bus and a bus driver.

Daugherty recalls riding on a city bus when her daughter was attending Allen School, a private school for girls. The bus driver informed her that sitting three seats from the back was not far back enough, as white passengers boarded. Years later, the driver, not recognizing her, came to her front door seeking her vote in his campaign for town councilman.

"He was so polite," Daugherty reflects. "He didn't win."

World War II affected race relations as well as world relations, since President Truman had desegregated the armed forces. Gladys Uzzell, owner of Uzzell's Drug Store, was once in tears after friends had told her she should not serve sandwiches to returning African American soldiers. "You'll lose business," her friends had advised. Gladys responded, "I'll feed them even if I never sell another thing in this store."

PART V
TALES OF ADVERSITY AND TRIUMPH

L.B. Jackson
Tower Builder

T he first impression that newly arrived architect Henry Gaines got of Asheville in 1925 as he took his first stroll around the little metropolis was seeing a neatly dressed young gentleman stepping out of an office building on Pack Square into a chauffeur-driven, convertible Rolls Royce. The squire was twenty-eight-year-old Linwood Baldwin Jackson (called L.B.), and the building was his latest creation, the first skyscraper in Western North Carolina—the Jackson Building.

It was an unusual moment in L.B. Jackson's life. He had begun to turn his manufacturing fortune into a real estate career, having just built his first two homes on Edwin Wiley Grove land along Kimberly Avenue. Asheville was a boomtown, and Gaines caught him uncharacteristically putting on the Ritz. As Jackson's son, Linwood Jackson Jr., recalls, L.B. hated Rolls-Royces—he once tried to give his away—and preferred the rugged dependability of a Ford or Buick.

Yet Jackson was a showman. In the interest of making friends and being the entrepreneur, he fashioned business schemes with admirable style. "See L.B." signs stenciled the skies in the Land of Sky; and a searchlight atop the Jackson Building projected a beam that could be seen for a hundred miles.

Jackson was the fifth child of six born to a building supplies merchant and his gentile wife in Georgia in 1896. He was the first child born in the mansion that had been his father's dream since gazing at it across from the college he'd attended as a boy. After Jackson's mother, Marguerite Garland Jackson, died of the mumps, his father, Edmund Albertus Jackson, asserted that L.B. was the one child about whom he worried the least.

Little Linwood learned to walk by his first birthday, the result of a bet that his older sister, Alberta, had made with their Uncle Edgar. For her faith and effort, Alberta won a silk embroidered parasol and became the envy of every girl in Coleman.

L.B. grew up with a sense of special purpose. When cousin Scott Baldwin ignored little Linwood on a visit to the Jackson home, Mrs. Jackson, deeply hurt, rescinded her boy's middle name, Scott, and replaced it with the more generic Baldwin.

Short in stature, L.B. stood out among men. His high school graduation class photo shows him alone in a second row between the well-dressed young men in the top row and the corsage-wearing ladies in the first. As early as age eight, he

The neo-Gothic Jackson Building was the first skyscraper in Western North Carolina, built with steel from Asheville Supply and Foundry, located behind it. *Photo courtesy of North Carolina Collection, Pack Memorial Library.*

had learned to turn his spunkiness to advantage, dressing up in shirt and tie to win customers in his first business venture, peanut vending.

Investing his savings in a used peanut parcher, L.B. set up shop in front of his father's store by the Cuthbert Railroad station to sell nuts to the town's laborers. A few years later, he expanded, buying another parcher and granting his younger brother, Winston, a franchise.

Winston, later engineer for L.B.'s commercial building projects, vividly recollected his brother's stab at another career, theater. In 1910 the center of Cuthbert highlife

was the movie house, where, every Saturday night, the management awarded five dollars to the winner of a talent show. L.B., Winston recalled, set his sights on winning that prize, thinking that it was an easy way of earning a lot of money, and proceeded to study music, histrionics, the whims of the judges and the acoustics of the auditorium.

In a ruffled minstrel suit he had bought for the occasion, L.B. strutted around the stage in a practiced gait, singing "Mammy" a la Al Jolson at the top of his voice. The audience, judging with applause, could not decide between him and another child, so the theater manager split the prize.

"Before the performance," Winston said, "all that he [Linwood] could talk about around the house was that he was going to be an actor...After the performance, he wrapped up his vaudeville clothes, packed them away, and never did take them out again."

When Edmund Jackson moved to Asheville in 1914 to establish a factory for Chero-Cola, a new company with headquarters in Columbus, Georgia, L.B. offered his father $5,000 to help get it started. While Edmund's other sons supervised operations, L.B. took to representing the company on the road, traveling the Murphy line, stopping in railroad towns to take orders for soda and to chat. Back in the factory, gauging production, L.B. applied himself to the bottle inspection problem he perceived.

In order to make sure that no bottle went out with impurities, assembly line workers had to hold up two bottles to a blinding light, risking an explosion if the carbonated receptacles clanked. U.S. Patent number 1,204,664 covers Jackson's 1916 "bottle tester" invention. With it, a worker could load four bottles into a die-cut lid, and, by closing the lid on a light box, both agitate the contents and turn on the light. A year later, he sold the invention to another bottling company for $20,000.

It was on his travels, selling cola and attracting investors, that Jackson saw the value in punchboards, honeycombed countertop lottery machines by which a nickel afforded store customers a chance at a prize (most fortunately, a 2½ dollar gold piece). Jackson had boards manufactured in Chicago, enlisted salesmen and established a network of locations. He cleared a profit of $1,000 a day until anti-gambling laws shut down such operations two years later.

In contrast to Arthur Miller's tragic American salesman, L.B. Jackson represented the ever-optimistic all-American salesman. He loved the road, getting up at 5:00 a.m. to explore Asheville's country ways, the back of his Ford stocked with canned food. He also loved the roller coaster of finance. "There is a tide when taken at the flood leads to fortune," Jackson liked to quote. "I attribute my success largely to chance."

After developing neighborhoods such as Royal Pines; building hundreds of homes along Kimberly Avenue, in Beverly Hills and elsewhere; and completing

such commercial projects as the Jackson Building, the Flatiron Building and the Grove Arcade, Jackson was felled by the Depression. Despite owning a $20 million fortune, the informal agreements he had with homeowners regarding their assumption of mortgages for his spec homes left him holding the bag when the banks came calling.

Jackson lost everything and then, counting on friendships, got it all back. He sold the Jackson Building and then rebought it, establishing his new office on the ground floor so that he could have regular contact with passersby. He built the first Federal Housing Authority–financed home in Asheville at 201 Kimberly Avenue in 1936. It is reputedly also the first Asheville home with a picture window. In 1937 he became a major developer for the National Linen Company.

Popularly associated with the spirit of the twenties, L.B. Jackson also epitomized the spirit of the thirties—a time, his son, L.B. Jr. said—when people let their hair down and survived through friendship and humor. Once, his poker-playing buddies stashed moonshine in his car trunk and called the police on him; he returned the joke by instigating a police raid on a gambling party he had bowed out of.

No one could resist L.B. Jackson, his son eulogized. "Dad could sit down with anybody and talk on a subject and be knowledgeable. If you were a banker, he knew how to talk bank talk; if you were an engineer, he could talk engineer talk. He was a real, honest-to-goodness promoter."

Fellowship and Fashion Gave Jewish Merchants a Foundation

A sheville's Jewish pioneers entered town on a silk road, many of them arriving to operate as the city's clothiers. They also followed the path of pots and pans, establishing dry goods stores downtown after having served for decades as mountain peddlers.

"Records reveal at least two Jews among the pioneers of the 1880s," the late Leo Finkelstein, a popular merchant, noted in his paper "The Jews of Asheville." In 1887 Louis Blomberg moved here from Aiken, South Carolina, to establish The Racket Store, a clothing emporium. At the same time, Morris Meyers, a traveling salesman, arrived, hooking up with his brother-in-law, Solomon Lipinsky, at Bon

Marche department store, and eventually establishing his own place—Palais Royal—famous for its newspaper spreads advertising sales of everything from carpets to corsets.

By 1900, North and South Main Streets (now Broadway and Biltmore Avenue) were dotted with a variety of clothing shops owned and operated by Jewish merchants and tradespeople, forming the nucleus for a much wider Jewish community and necessitating two synagogues—congregation Beth Ha-Tephila, Reformed, and Bikur Cholim (later Beth Israel), Orthodox.

Although anti-Semitism expressed itself in Asheville, the city's bedrock citizens embraced their amiable and progressive new fellows without prejudice. Morris Meyers was elected the first Exalted Ruler of the local Elks Lodge (#608). And Harry Finkelstein, who opened what is supposed to have been North Carolina's first pawnshop at 23 South Main Street, supplied the sheriff's department with guns whenever Asheville had a criminal crisis.

Harry Finkelstein's son, Leo, continued his father's work and rose to such heights of popularity within the Asheville Lions Club that, in 1939, they purchased a lion couple from the Jacksonville zoo and named the felines' first son after him.

Leo Finkelstein loved to entertain his fellows with humorous personal stories. His written record of these tales—preserved by his son, Leo Jr., and by the Center for Appalachian Studies at Appalachian State University—is a large part of his legacy.

For instance, there was Rabbi London, the first rabbi of Bikur Cholim, a model of civility. He operated a grocery store on the side, and was known to remove his hat whenever he got a phone call from a woman. And then there was the dedicated black minister, who during the Depression, in order to keep himself going, pawned his Bible on Monday and redeemed it on Friday.

Siegfried Sternberg, vice-president of Southern State Bank, owned a junkyard on Depot Street and advertised, "We buy anything and sell everything." A traveling circus, needing a loan while in town, once left Sternberg an elephant as collateral. Finkelstein relates: "Mr. Sternberg…complained he was losing money on account of the elephant eating so much. Otto Buseck, who owned Middlemont Gardens at that time, raised his own flowers at a hot house in Candler. He helped Mr. Sternberg out with his elephant—he bought the animal's manure."

Leo Finkelstein's stories about human virtues and foibles helped form a bond with a community that was used to a very similar brand of humor—the kind of mountain tale that Loyal Jones is famous for collecting. Finkelstein's masterpiece is "I Am a Dime," the coin's own narration of its birth in Philadelphia and its adventures in Asheville, reflecting jokingly on a number of Finkelstein's friends.

Siegfried Sternberg, the story goes, first received the dime at his bank and then took it to a poker game at his Victoria Road home, where, in a police raid tipped off by a prankster, it became the property of Chief Bernard. Mr. Finkelstein named

the players with the first eight letters in the Hebrew alphabet: Mr. Aleph, Mr. Baze, Mr. Gimmel and so on.

The dime then connects the fates of a Greek restaurateur; a shoeshine boy; a streetcar conductor, Leo, on a fishing trip; an attorney; a thief; a hot dog vendor; and the Lion Club's Tail Twister, among others. For several years, it circulated in a slot machine at the Lions Club when, in 1950, Dr. Leon Feldman won it. "Dr. Feldman," the dime concludes, "put me in the zipper change section of his pocketbook, and now I haven't seen the light of day for twenty years."

Finkelstein had saved the last jibe for his best friend, the doctor and boxing official who was so popular that three local restaurants named sandwiches after him.

Nina Simone
Tryon Jazz Singer

F red Counts remembers walking down from Cemetery Side (also called Eastside) in Tryon with his friend, Eunice Waymon, in the early 1940s to buy sodas at Owens Pharmacy. "I don't think we serve the same God," said Eunice, who later gained fame as Nina Simone, internationally lionized singer, pianist and songwriter. "They [the white customers] can sit under the Casablanca fans," she noted, "and we have to keep walking to drink our sodas."

In a 1997 interview, Simone, an expatriate in France, said that she remained a rebel with a cause, the cause being "the direct equality of my people around the world." A couple of years later, she returned to Tryon for her mother's funeral. Suffering with the cancer that would kill her in 2003, Simone barricaded herself within a ring of security guards.

The guards stopped Counts on his way to visit Simone, but she interposed herself and admitted him. He advised her to have no regrets about the past. "You had the talent to go to the top, and the character to stay there for more than forty years," he said. "We who fought racism got more relief from it than those who hid away."

Counts was, among other things, a celebrated Tryon All-stars shortstop who, because of segregation, had gotten no shot at the Major Leagues. Today, he serves as an inspiring presenter of programs about Dr. Martin Luther King Jr. and African American poets.

The sharpness of Simone's convictions may be due to the contrast of hurtful times and good times that she'd experienced. She had grown up within an island of

The house on Livingston Street in Tryon in which Nina Simone spent her first years has been rescued by a private owner. *Photo by author.*

communal support, set off from a disdainful society. The view from the Waymon family's hilltop home (now an object of historic preservation) reveals a neighborhood nestled in a circle below it. The Waymons' twenty-two-by-twenty-six-foot house, presided over by two admired parents, had once resonated with joyful organ music.

At age three, Eunice, sixth child of eight, proved to be a piano prodigy and at age six, performed hymns in the St. Luke CME Church, where her mother was minister. At a church on Peake Street, Simone discovered African rhythms. In her autobiography, *I Put a Spell on You*, she confided, "I took to going to the Holiness services every week just to get into that beat."

Tryon's colony of artists and reformers latched onto Eunice with love. Tom Moore remembers how his mother, Esther Moore, Eunice's mother's friend and employer, paid for Eunice's piano lessons. Every day for six years, the girl walked two miles to her tutor, Mrs. Mazzanovich, to embrace classical composers and classic composure.

"Tryon's white people wanted to make her [Nina] into the Marian Anderson of concert pianists," says Mike McCue, author of *Tryon Artists 1892–1942*.

At age eleven, Eunice gave a concert at Lanier Library and underwent the shame of seeing her parents moved from the front row to the back. It stung her badly.

"The racial climate of Tryon was more complex than I had thought," says biographer Nadine Cohodas. For Simone, circumscribed by music, family and Tryon's patronage, the specter of Jim Crow was a shock.

Double Lives

While contracting as a caterer in the home of Esther Moore in Tryon, Mary Kate Waymon served as a minister in the St. Luke CME Church in Eastside, a nearby African American neighborhood. She had two lives: one rooted in tradition, the other adapted to the wealthy, progressive, white community that had colonized Tryon in the late nineteenth century.

Moore treated Waymon with dignity and, recognizing the prodigal talent of Waymon's daughter, Eunice, paid for her to take piano lessons with another cultural import, Muriel Mazzanovich, English wife of a Croatian-Italian painter. From this connection emerged Nina Simone, Eunice's stage name when she started pursuing musical fame up North several years later.

Mary Kate Waymon was good friends with Della Hayden Davenport Jackson, a teacher and civic leader from Stony Knoll, five miles from Tryon. Jackson attended Waymon's church.

Della had been the first member of her family, in 1923, to attend high school, traveling to Allen School in Asheville. She later attended and graduated from North Carolina Central College in Durham, returned home to teach, and in 1937 established the Stony Knoll Community Library, still a bulwark of African American heritage.

Della's daughter, Evelyn Petty, who now runs the library, recalls her mother's activism as well as the effects of the rich white community on the rural population. "My aunt," says Petty, "worked in Tryon for Carter Brown," Pine Crest Inn proprietor and the horseman who introduced foxhunting to the area. "She stayed on the premises most of the time. When she came home, she brought presents and told us how to do things properly."

With the special relationship between white and black residents, Tryon took a step ahead of other communities in the South by incorporating segregated schools into a consolidated system as early as the 1930s. The African American schools received support. Still, the racial divide cut deep.

Mamie Thompson Gumbs, curator of the Maimy Etta Black Historical Society and Museum in Forest City, played basketball with Eunice Waymon in the early 1940s—on outside courts even in snow, for they had no access to indoor ones. Eunice never spoke of the patronage she was getting from Mrs. Moore and others. "Everything was like a secret," Gumbs says. No one wanted to endanger white folks who were helping.

Theresa Price Bennings, Forest City native, studied the Bible under Eunice's mother, Mary Kate, and led a parallel life to Eunice. When she was six, a white stranger insulted Bennings for drinking from a fountain in a park her father was cleaning.

Like Eunice, Bennings went to New York to make a living when she reached maturity; and, like her, she exhibited spunk. Wanting to get beyond

her postal clerk job and sweltering Bronx walkup, Benning went to see the mayor, Robert Wagner.

"Your Honor," Bennings said, "I come from North Carolina and believe I can be an asset to your city." Wagner found her an apartment in grassy Throgs Neck and secured her a scholarship to Baruch College.

Integration Makes Friends of Engineers

One of the best places to have seen racial integration at work in Asheville was on the Southern Railway in the mid-1960s. Required to advance African Americans to skilled positions, company officials did so suddenly, placing black recruits among white workers with seniority. It was a policy guaranteed to foster resentment, yet the nature of railroad jobs—hard, dangerous and dependent on teamwork—enabled employees to shed attitudes and judge their fellows on the basis of performance.

James Harrison, an African American insurance salesman, was hustled to Atlanta for training as a conductor in December 1964—one week after the session had started. His first challenge was to catch up with the other students on his own.

Back in Asheville, armed mostly with book knowledge, he faced another test—making decisions that required on-the-job experience. Eventually assigned the flagman position on conductor Paul Ross's crew, he computed tonnage—determining if a given engine could make it up a mountain grade with its load of cars.

Ross took Harrison under his wing, teaching him the intricacies involved in reducing cars, knowing that he'd be a conductor one day. Kindnesses "like that count," Harrison says. "For instance, Bill Kemp, an engineer, told me, 'Use your Vaseline on your feet and your hands. They have to last you thirty years.'"

Ross recalls Harrison's initiation: "James proved to me that he was going to do the work and not act like he wasn't going to do something because I was picking on him. That's when I became close to him."

Shared hardships also bound railroad men. They faced suspensions if they showed up late for work. Trainmen had to be at their phones for calls. The "Casey Jones" lyric, "caller called Casey at half past four," is no fiction, and Casey was lucky to have "kissed his wife at the station door."

Part V: Tales of Adversity and Triumph

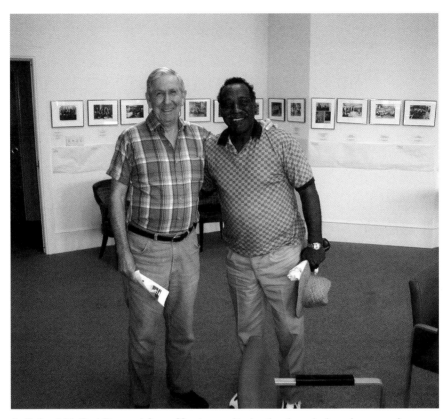

Left to right: Paul Ross and James Harrison, retired railroad conductors, began work on the Southern Railway in Asheville in 1955 and 1965, respectively. Their stories form part of YMI Cultural Center's "Ties that Bind" project, a documentation of Western North Carolina's railroad since the 1870s from an African American perspective. *Photo by author.*

Between runs, trainmen had eight-hour breaks, devoted in part to family life and often interrupted by nighttime calls to start another sixteen-hour shift. "I used to think it was against the law to run the trains in the daytime," Ross jokes. "When the phone rang in the middle of the night, my wife got out on one side of the bed, and I got out on the other and answered the phone. By that time, she'd have put the coffee on and started breakfast."

Sleep deprivation was institutionalized. "You'd get so tired, you couldn't even count sixteen hours," Harrison says. Ross notes, "My favorite thing was to wash my face with cold water and beat my head against the wall...If [the inspectors] caught you with your eyes shut, you were out of a job."

"They rode up and down the road looking for that," Harrison confirmed.

You hear Harrison and Ross talk about kicking and jerking trains at the Marion switcher, performing a wordless choreography with fifty-ton machines, and you understand the camaraderie that transcended social ills.

The Flourishing African American Music Scene

Every Christmas in the late 1950s, Jerome "J.C." Martin, a celebrated bass player, had asked his parents for a guitar that improved on the one he'd gotten the year before. At age nine, he'd sit on his porch and, with a plastic instrument and amp, accompany the soul brothers whose sound emanated from the Owls Lounge nearby.

The Owls Lounge had been a landmark nightspot in Southside, an African American neighborhood cleared away in Asheville's urban renewal program in the 1970s. Such changes weakened a music scene in which performers had been nurtured by church spirituals, school programs and a lively marketplace of gospel, soul and jazz.

Kids aspired to emulate their elders. Martin joined friends to form a group called the M-Tears. "We rehearsed for three years and never played a gig," Martin told Pat McAfee, compiler of an archive of this region's black gospel and secular music.

"We were barely out of elementary school," Martin continued. "But finally we did our first gig under a shed on Murray Hill." It wasn't for money, but it was a first step.

A decade later, Ruben Mayfield, a trumpet and saxophone player, was experiencing the same sensations. At age fourteen, he got a job at the Owls Lounge. Subsequently, he joined the Outcasts, winners of a statewide Battle of the Bands competition in 1979 that named them the number one R&B, Soul and Top Forty band in North Carolina. Pat McAfee was the lead singer.

"One time when we were backing up Z.Z. Hill," Mayfield relates, "he wanted Pat to sing his hit song ["Love Is So Good When You're Stealing It"] with him. He wanted Pat to get down on her knees [while he stood], and as hard as he tried to push her down, she wouldn't go."

It wasn't easy for Asheville performers to negotiate the big time. But there were moments of grace.

Mayfield went to an audition at the Kitty Kat Club on Biltmore Avenue for a spot with the Innersouls, a local band that toured widely. He had no instrument case for the tenor sax he was carrying, and police stopped him on suspicion of theft. "My horn was so raggedy, you could hit the neck and it would spin around," Mayfield recalls. He'd proved his ownership by playing it.

After the audition, Bonnie Clyde, one of the Innersouls members, asked to see Mayfield's horn. "He took a look at it," Mayfield says, "grabbed it like a baseball bat, and slammed it into the brick part of the stage platform…He turned to me and said, 'Now let's get you a real horn.'"

As society changed, some of the region's best African American musicians devoted their talent to churches, many more of which became receptive to horns and drums in their services. "I told the Lord I would start playing for Him," Martin confides. Still, he says, "I just love to hear a guitarist bending those strings; I love to hear a bass player poppin'; or even laying back with a slow bass walk."

Exodus to Arden

Like the farmers in Buncombe County in the 1920s, farmers in 1990s El Salvador left bountiful farms to help their children keep pace with society. They moved to homes close to good schools. Fathers took city jobs.

Maria and Juan Carballo—formerly of the mountains of El Salvador, and presently of Arden, North Carolina—had had dreams of advancement for their offspring when, in 1992, Juan obtained a visa to work in a factory in Rhode Island. With her husband's new earnings, the eldest daughter Roxana recalls, her mother put a down payment on a house in San Miguel, a city located a walking distance of two hours from the family farm.

Electricity, buses and a hospital had been absent in the Carballos' rural community, yet a kind of prosperity had existed there. The farm, belonging to Juan's father, boasted cows, pigs, orange trees and vegetable crops, the products of which were carted to market to feed urban dwellers. "We had a lot of free time," Roxana recalls. "We played around. We drank water, not soda."

After a few years in Rhode Island, Juan Carballo heeded the call of a relative in Oakley and got a job in one of the factories in this area that depend upon Hispanic workers. Soon, Maria followed. "I didn't want my husband to be alone," she says. "On the way here, I learned that my mother became sick and, eight days after my arrival, she died."

An exodus has a great cost, and makes heroes. In 1997 Maria beckoned Roxana to join her. "That was a Sunday," Roxana remembers. "I packed up Monday. I left Tuesday and drove to California, where an aunt lives, and then flew here." A year later, Roxana learned via a phone call during breakfast, that one of her four not-yet-united siblings, Ronald, had drowned in a river in California.

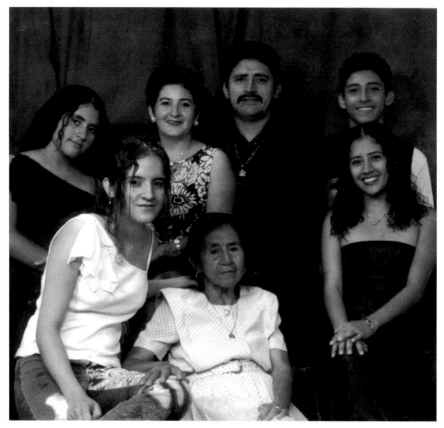

The Carballos of Arden. *Top row, left to right*: Rubidia, Maria Guzman, Juan and Henry. *Bottom row*: Patricia, Ciriaca (Juan's mother) and Roxana. *Photo courtesy of Roxana Carballo.*

By 2003, Juan and Maria both worked in factories fifty hours a week. Roxana, the only employment-aged child, was managing a restaurant job as well as her family's paperwork and an undergraduate education. Her goal is a career as a lawyer, helping Spanish-speaking people.

The Carballos are a mannerly, traditional family. Their first home in Buncombe County, a trailer park in which people played loud music, made them flee to quieter surroundings. Adapting to American customs is hard, as Roxana discovered accompanying her restaurant friends to pool halls. In contrast, when Roxana goes out on dates, she requires a chaperone, usually her teenage brother, Henry.

The Carballo dream required abrupt change, and the family retains only two keepsakes from El Salvador—a video of a memorial service that community members had held for Ronald; and a video of a Salvadoran Independence Day parade in which a daughter, Rubidia, had served as queen.

Who is Festus?

Anyone going north on Riverside Drive past the I-240 overpass in Asheville sees it—one of the most appropriate memorials in the region. A white cross anchored into the pier of the railroad bridge there bears the name "Festus." Who is Festus? people wonder.

On Saturday night, August 31, 2002, David Allen Walker, nicknamed "Festus" by his middle school football coach years before, died when his pickup truck slammed into the monstrous bridge support. By fashioning the memorial, friends Mark McIntosh, Kerry Putnam and others achieved additional purposes.

The cross serves as a warning: accidents happen here. It also functions as a safety measure, a bright reflector on a concrete mass.

Karen Eavenson Walker, David's wife, has created other poignant memorials at home. She continues to perpetuate a father-presence for her two children, Cameron, fourteen months old when his father died, and Neyland David Walker, who never knew his father alive.

Neyland is named after the University of Tennessee's football stadium, home to David's favorite team. In addition to their mother's memory books and a trust fund buttressed by the Biltmore estate, David's former employer, the children each have a quilt that their great-grandmother, Mary Walker, made out of David's Volunteer T-shirts. Glimpsing her work-in-progress at Christmastime, Cameron said, "I can't wait to take it to bed. It'll feel like his arms are wrapped around me."

Memorials also involve symbolism. During the 2004 floods, Karen's father's secretary noticed as she left her workplace on Emma Road that the flood waters had stopped just below the cross and that the sun was illuminating it—a symbol of survival.

Finally, there are the issues that go beyond any one individual—in this case, the epidemic of vehicular death. Less than a year before Walker's accident, officials at the State Department of Transportation were claiming that the increasing number of highway roadside memorials were creating a dangerous distraction. It brought to mind the crosses on I-40 near Black Mountain, which mark where Montreat College students Brian Anthony and Kerri Kennedy had been killed by a median-crossing tractor-trailer on October 10, 1998.

Brian's father, Tony Anthony, of Jonesville, said he thought the memorials served as a reminder for drivers to be more alert. "My son paid the price for that." Kerri's mother said, "Having lost my daughter up in North Carolina, I feel like that's where her spirit is."

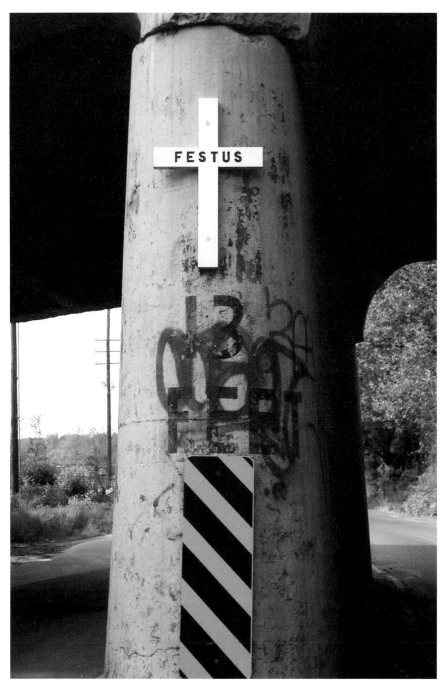

Riverside Drive heads directly toward the pier of a railroad bridge before hooking right through an underpass. David "Festus" Walker died when his truck collided with the pier. *Photo by author.*

There's another memorial on I-40: guardrails. The students' deaths spurred an extensive guardrail installation project by the DOT in 1999.

West Asheville Businessman's Life Inspires a Ballad

Mountain news once traveled by ballad. Taking a page from that oral tradition, this portrait of a West Asheville man employs a ballad's perspective, finding a community's self-image reflected by an individual's struggles-of-the-moment.

Jack Fortune is the man. Born Stonewall Jackson Fortune, sixth child of nine in a Broad River family, he set out at age sixteen to get a job on the Southern Railway and secured one of its most dangerous positions—brakeman. At the time, 1906, the Southern Railway Company was competing with the South and Western Railroad Company to be masters of the mountains, and their business attitude was full steam ahead.

Looking back at his apprenticeship, Fortune used to tell a story about a heavy freight train that had been barreling down Saluda Gap on the Spartanburg line when its air hose broke. He had to climb atop the train to turn the manual brake on each car.

On any given night, applying hand brakes on mountain grades put brakemen in grave danger. Trains barely cleared the tunnels that had been blasted through Appalachian rock, and the railway had to hang "dead man's" warning ropes a distance before tunnel mouths to help the brakemen avoid decapitation.

In 1906, young Fortune could have read in the *Asheville Citizen* about several serious accidents to railroad workers. On January 17, for instance, Conductor Claude C. Dermid was crushed to death while coupling two cars in the Balsam yard.

The same day's paper also prefigured Fortune's future home. An announcement told of William Logan's purchase of twenty-one acres in West Asheville for a new subdivision.

Misfortune struck four years later.

In 1910 Jack Fortune was switching freight cars in the Old Fort Yard when a gravel-jammed switch pitched him under the wheels of a moving engine. He lost

Stonewall Jackson Fortune lost both legs in a railroad yard and became a successful businessman. *Photo courtesy of Albert Fortune.*

both legs. Treated by Biltmore Hospital intern and future doctor Arthur Pritchard, Fortune labored over several years to regain a full life. He acquired prosthetics and learned to use them, went to business school, married and started a family. Following the loss of his wife to pellagra, Fortune migrated to Asheville and then to his land of opportunity, West Asheville.

When in 1920, Fortune established the Ideal Paint and Varnish store, later Ideal Paint and Hardware, on Haywood Road, he was one of a handful of pioneer businessmen in the growing district. Like many of these men, he maintained a home farm—having come from the country and wanting his children to learn country values—and, like other West Asheville men, he nearly worked himself to death. Albert Fortune, his son and biographer, notes that in 1935, Jack Fortune traveled to the Mayo Clinic in Minnesota with a stomach ulcer and suspected cancer. Dr. Mayo's high-priced prescription was: "Take off from work one day a week and go fishing."

Albert Fortune became one of the co-founders of the West Asheville Business Association, whose members served as some of Jack Fortune's pallbearers at his funeral in 1966. The honor fulfilled a wish expressed by the last verse of the following original ballad.

Part V: Tales of Adversity and Triumph

Ballad of Jack Fortune

He was sixteen years and maybe a day
When he headed to the city and the Southern Railway.
They'd finally topped the mountain grade
And were looking for men and offered good pay.

This is the story of a hard-working man
And the open road of a highway plan.
Many looked for fortunes, but he was one—
Stonewall Jackson Fortune.

I'm a-going to my home,
Steady job and a family farm.

There's a train that comes down Saluda Gap,
The danger zone on the topo map.
When you need more brakes, you've got to climb on top.
Before each tunnel there's a warning flap.

On a fateful day in the Old Fort Yard,
Gravel jammed the switch and it stuck hard.
Then it came loose, caught Jack off guard,
And his legs were trapped beneath moving cars.

Refrain

There are limbs new made with industrial tools,
And dreams that climb on business schools,
And fruits of labor on hardware aisles,
And a place in the sun in West Asheville.

When I die, let me be borne
By the men whose shoulders this town rests on.
My life's a story and this is a song
About what should last when all is gone.

Refrain

Bibliography

Much of the material used for this book came from personal interviews, private papers and limited editions of family genealogies. However, a number of generally available sources have proven critical in supplying and verifying information, as well as providing the background, insight and anecdotal material that help make history come alive.

In addition to the books and online sites cited below, the following encyclopedic resources have proven useful repeatedly: the bound clippings files at Pack Memorial Library; the Liston B. Ramsey Center for regional studies collection at Mars Hill College; city directories; newspapers on microfilm; *The Journal of Cherokee Studies*; Heritage Books for the counties of western North Carolina; *The Official Records of the War between the States*, published by the U.S. Army; and county records of property deeds.

In a separate category from personal sources for individual stories are the local historians whose expertise about the region has provided wide-ranging analysis and consultation: Dr. Barbara Duncan; Albert Fortune, Terrell Garren, Ted Darrell Inman, Dr. Ken Israel, Pat McAfee, Michael McCue, Dr. David Moore, Frank Roberson and Dan Slagle—just to name the ones who have had an influence on this volume.

Books and Media

Ager, John Curtis. *We Plow God's Fields: The Life of James G.K. McClure*. Boone, NC: Appalachian Consortium Press, 1991.

Alley, Judge Felix E. *Random Thoughts and the Musings of a Mountaineer*. Salisbury, NC: Rowan Printing Co., 1941.

Arthur, John Preston. *Western North Carolina: A History (from 1730 to 1913)*. Asheville, NC: Edward Buncombe Chapter of the Daughters of the American Revolution, 1914.

Bartram, William. *The Travels of William Bartram*. 1791. Edited with commentary and an annotated index by Francis Harper. New Haven: Yale University Press, 1958.

Black History Research Committee of Henderson County. *A Brief History of the Black Presence in Henderson County*. Asheville, NC: Biltmore Press, 1996.

Blackmun, Ora. *Western North Carolina: Its Mountains and Its People to 1880*. Boone, NC: Appalachian Consortium Press, 1977.

BIBLIOGRAPHY

Boughman, Arvis Locklear, and Loretta O. Oxendine. *Herbal Remedies of the Lumbee Indians*. Jefferson, NC: McFarland & Co., 2003.

Clark, Walter, ed. *Histories of the Several Regiments and Battalions from North Carolina, in the Great War, 1861–1865*. 5 vols. Goldsboro, NC: Nash Brothers, 1901.

Cooper, Leland R., and Mary Lee Cooper. *The People of the New River: Oral Histories from the Ashe, Allegheny and Watauga Counties of North Carolina*. Jefferson, NC: McFarland & Co., 2001.

Duncan, Barbara C., and Brett H. Riggs. *Cherokee Heritage Trails Guidebook*. Chapel Hill: University of North Carolina Press, in association with the Museum of the Cherokee, 2003.

Dykeman, Wilma. *The French Broad*. 1955. Reprint, New York: Holt, Rinehart and Winston, 1974.

Ellison, George. *Mountain Passages: Natural and Cultural History of Western North Carolina and the Great Smoky Mountains*. Charleston, SC: The History Press, 2005.

Finkelstein, Leo. *Leo Finkelstein's Asheville and the Poor Man's Bank*. Edited by Patricia Beaver. Boone, NC: The Center for Appalachian Studies, Appalachian State University, 1998.

Finley, Reverend James B. *Sketches of Western Methodism*. Cincinnati, OH: Methodist Book Concern, 1854.

FitzSimons, Frank L. *From the Banks of the Oklawaha*. 3 vols. Hendersonville, NC: Golden Glow Publishing Co., 1976–1979.

Frazier, Charles. *Cold Mountain*. New York: Atlantic Monthly Press, 1997.

Gaines, Henry Irven. *Kings Maelum*. New York: Vantage Press, 1972.

Garren, Terrell T. *Mountain Myth: Unionism in Western North Carolina*. Spartanburg, SC: Reprint Co., 2006.

Gennett, Andrew. *Sound Wormy: Memoir of Andrew Gennett, Lumberman*. Edited by Nicole Hayler. Athens: University of Georgia Press, 2002.

Greenlee, Nina. *Stories Not Told in History Books*. Marion, NC: Mountain Mist Books, 2003.

Griffin, Clarence W. *History of Old Tryon and Rutherford Counties, North Carolina, 1730–1936*. Asheville, NC: The Miller Printing Co., 1937.

Hatley, Tom. *The Dividing Paths: Cherokees and South Carolinians through the Revolutionary Era*. New York: Oxford University Press, 1995.

Hilderman, Walter C., III. *They Went into the Fight Cheering! Confederate Conscription in North Carolina*. Boone, NC: Parkway Publishers, 2005.

Inscoe, John C., and Gordon B. McKinney. *The Heart of Confederate Appalachia: Western North Carolina in the Civil War*. Chapel Hill, NC: University of North Carolina Press, 2000.

Jobst, Richard. "History of the Smith-McDowell House." Asheville, NC: Smith-McDowell House, n.d.

Jones, Alex H. *Knocking at the Door: Alex H. Jones: Member-Elect to Congress: His Course before the War, during the War, and after the War—Adventures and Escapes*. Washington, D.C.: McGill & Witherow, 1866.

Jones, Loyal, and Billy Edd Wheeler. *Laughter in Appalachia: A Festival of Southern Mountain Humor*. New York: Ivy Books, 1987.

Kephart, Horace. *Our Southern Highlanders: A Narrative of Adventure in the Southern Appalachians and a Study of Life among the Mountaineers*. 1922. Reprinted with an introduction by George Ellison. Knoxville: University of Tennessee Press, 1976.

King, Duane, with Ken Blankenship and Barbara Duncan. *Emissaries of Peace: The 1762 Cherokee & British Delegations*. Cherokee, NC: Museum of the Cherokee Indian, 2006.

Lawson, John. *The History of Carolina, Containing the Exact Description and Natural History of that Country*. London: W. Taylor and J. Baker, 1714.

Lewis, Thomas M.N., and Madeline Kneberg. *Tribes that Slumber: Indians of the Tennessee Region*. Knoxville: The University of Tennessee Press, 1958.

Manarin, Louis H., et al., compilers. *North Carolina Troops, 1861–1865: A Roster*. Multiple vols. Raleigh: North Carolina Office of Archives and History, Historical Publications, 1966.

Mann, Charles C. *1491: New Revelations of the Americas before Columbus*. New York: Alfred A. Knopf, 2005.

McCrary, Mary Jane. *Transylvania Beginnings: A History*. Transylvania County Historic Properties Commission, 1984.

McCue, Michael. *Paris & Tryon: George C. Aid (1872–1938) and His Artistic Circles in France and North Carolina*. Columbus, NC: Condar Press, 2003.

————. *Tryon Artists, 1892–1942*. Columbus, NC: Condar Press, 2001.

McRorie, Johnson Davis. *Knowing Jackson County: People, Places, and Earlier Days*. Sylva, NC: Jackson County Historical Association, 2000.

Mooney, James. *Myths of the Cherokee and Sacred Formulas of the Cherokee*. Reproduction of 1900 and 1891 editions. Nashville: Charles and Randy Elder Booksellers, in collaboration with Cherokee Heritage Books, 1982.

North Carolina Wildlife Resources Commission. *The Bear Facts: The Story of a National Treasure*.

Paludan, Phillip Shaw. *Victims: A True Story of the Civil War*. Knoxville: University of Tennessee Press, 1981.

Parris, John. *These Storied Mountains*. Asheville, NC: Citizen-Times Publishing Co., 1972.

Phifer, Edward William, Jr. "Burke: The History of a North Carolina County, 1777–1920, with a Glimpse Beyond." Morganton, NC: privately published, 1977. Revised edition, 1982.

Powell, William S. *The North Carolina Gazetteer: A Dictionary of Tar Heel Places*. Chapel Hill: University of North Carolina Press, 1968.

Shaffner, Randolph P. *Heart of the Blue Ridge: Highlands, North Carolina*. Second edition. Highlands, NC: Faraway Publishing, 2004.

Simone, Nina, with Stephen Cleary. *I Put a Spell on You: The Autobiography of Nina Simone*. New York: Pantheon, 1992.

Sondley, F.A. *A History of Buncombe County, North Carolina*. 1930. Reprint, Spartanburg, SC: Reprint Company, 1977.

Szittya, Ruth O. *Man to Match the Mountains: The Childhood of Zebulon Baird Vance*. Asheville, NC: Hexagon Co., 1980.

BIBLIOGRAPHY

Timberlake, Henry. *Memoirs, 1756–1765.* Edited by Samuel C. Williams. Johnson City, TN: The Watauga Press, 1927.

Traveller Bird. *Tell Them They Lie: The Sequoyah Myth.* Los Angeles, CA: Westernlore Publishers, 1971.

Trotter, William R. *The Bushwhackers: The Civil War in North Carolina in the Mountains.* Winston-Salem, NC: John F. Blair, 1988.

Tucker, Glenn. *Zeb Vance: Champion of Personal Freedom.* Indianapolis, IN: Bobbs-Merill, 1965.

Watford, Christopher M., ed. *The Civil War in North Carolina: Soldiers' and Civilians' Letters and Diaries.* Vol. 2, *The Mountains.* Jefferson, NC: McFarland & Co., 2003.

Online Sources

American Life Histories: Manuscripts from the Federal Writers Project, 1936-1940. Manuscript Division, Library of Congress. http://memory.loc.gov/ammem/wpaintro/wpahome.html.

D.H. Ramsey Library Special Collections and University Archives. University of North Carolina, Asheville. http://toto.lib.unca.edu

Special Collections. Hunter Library, Western Carolina University. http://www.wcu.edu/library/specialcoll

Whitaker, Bruce. "Days Gone By." *Fairview Town Crier.* http://www.fairviewcommunity.com/towncrier/days1.php

About the Author

R ob Neufeld grew up in Northern Appalachia (Rockland County, New York) and moved to Southern Appalachia (Asheville) in 1988, taking his central interest in local history with him. For several years he has written the book feature as well as the local history feature ("Visiting Our Past") for the *Asheville Citizen-Times*. He has created walking tours of Asheville and written and performed historical entertainments for such places as the Biltmore Estate and the Thomas Wolfe Memorial. He edited *The Making of a Writer: The Journals of Gail Godwin, Volume 1* for Random House and is working on Volume 2. He was a library administrator for many years and is now the director of Together We Read, Western North Carolina's twenty-one-county community reading program.

Visit us at
www.historypress.net